MOMENTS
WITH
MARIANELA

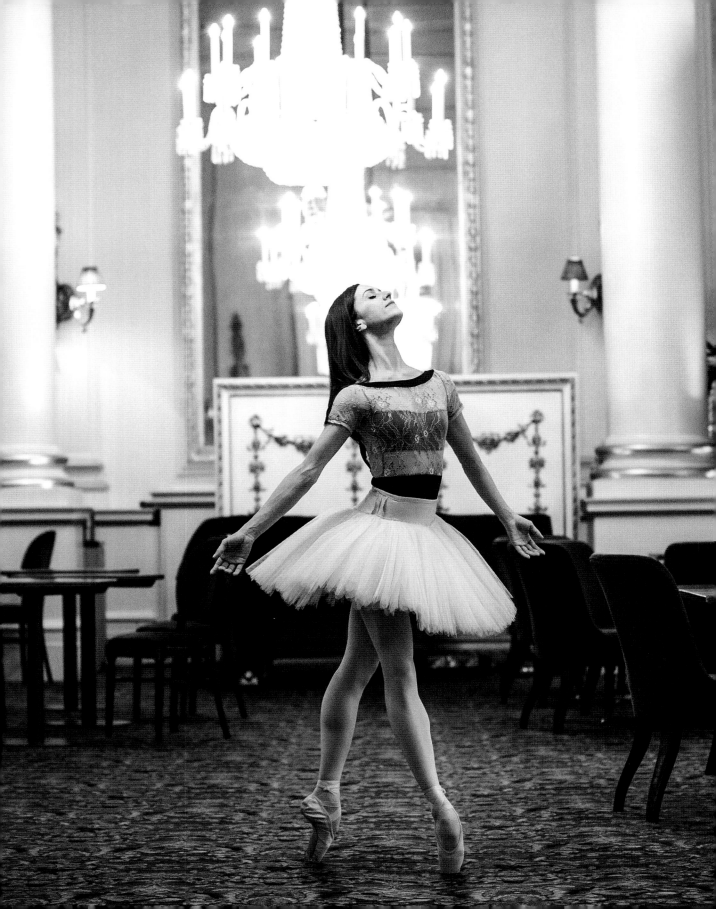

MOMENTS
WITH
MARIANELA

MARIANELA NUÑEZ
PHOTOGRAPHED BY
MARIA-HELENA BUCKLEY

ROYAL
BALLET

SCALA

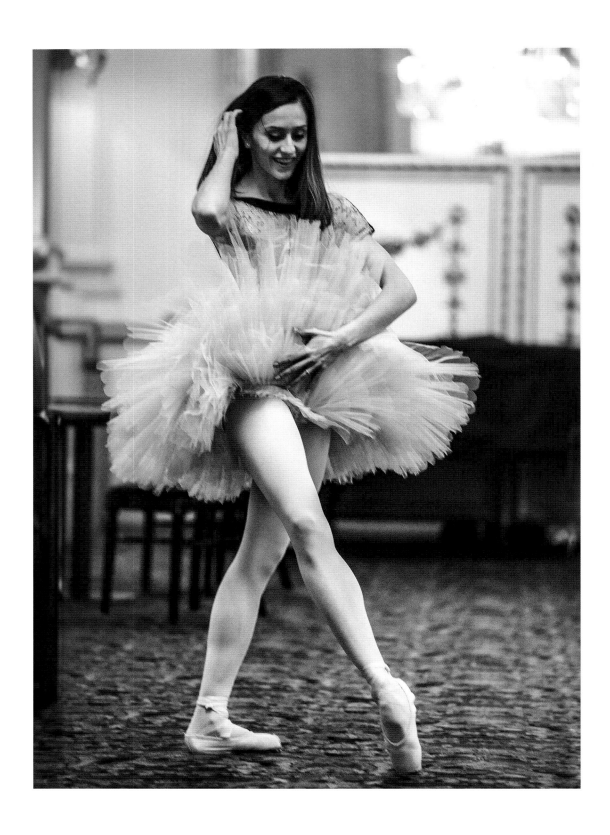

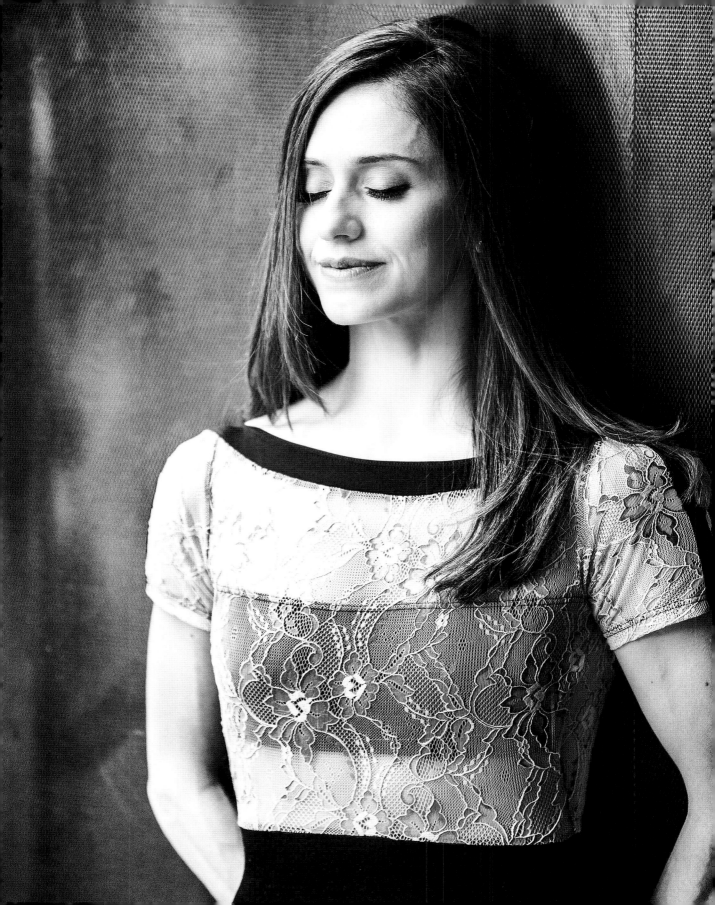

MOMENTS WITH *MARIANELA*

This book is not a definitive history of the stellar career of one of this century's most celebrated ballerinas. Nor is it a curated collection of favourite ballets performed. Rather, it is a document of a special relationship that developed during a five-year period on the occasional visits when photographer Maria-Helena Buckley took the train from Paris to London to capture The Royal Ballet's Principal dancer Marianela Nuñez in motion. It led to a body of work that speaks eloquently about two art forms: the art of ballet and the art of photography.

MARIA-HELENA:

One of my favourite images of Marianela is as Giselle. It was one of the first photos I ever took of her. It was her entrance in Act II and it was her 20th anniversary with The Royal Ballet. My husband was coming to teach the company and he said to Marianela that I was offering to take some photos. She was happy for this to go ahead and I was in shock that she agreed. You forget how big a star she is. I was immediately struck by her modesty and how unspoilt she was. The complete trust that she gave me was something very rare for an artist working at that level and it felt overwhelming. We had one day in the studio and one on stage. The whole process was strangely easy.

MARIANELA:

Our worlds are parallel. Ballet is my true love, my passion, and this is something Maria-Helena and I share. Of course, as a former dancer, she knows this life, this passion. Her photos are about beauty, about atmosphere. They create stories. She has an eye for the right moment to capture, a musicality that she brings to the camera, her tool. My instrument is my body, hers is the camera now. Photography is defined as drawing with light; that description evokes grace and radiance, elements that infuse dance. A camera captures an ephemeral moment and there is a sense of alchemic practice that feels akin to ballet, that perpetual cycle of something starting in the studio that leads to magic on stage. So I feel our experiences have truly come together in this collaboration.

MARIA-HELENA:

I found Nela an open book, generous in her dancing and her being. There is a complexity to her as a human. She is a mix of so many things. She is brave, fragile, both confident and unsure. These contradictions lead the way for so many emotions to be present in her dancing, and her sensitivities lead her to feel and interpret at a deep level as an artist.

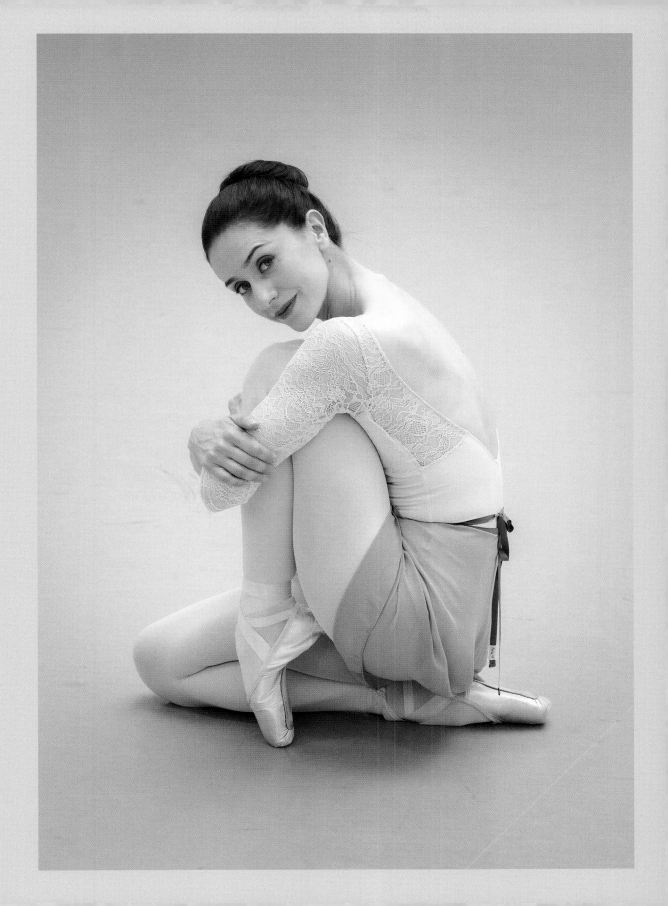

Ballet holds me.

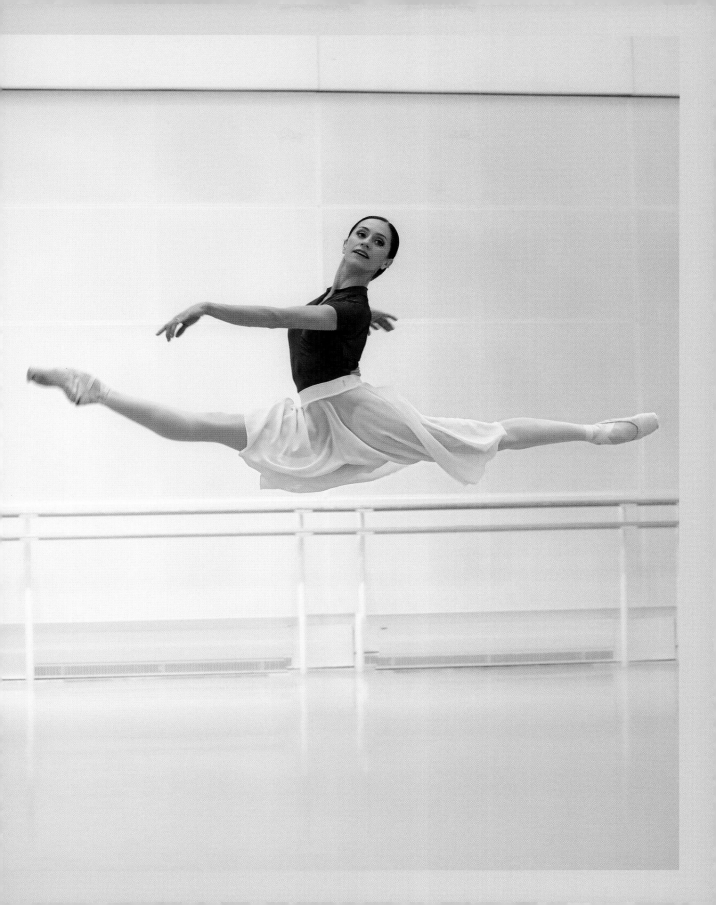

MARIANELA:

Humility feels essential to the art of ballet, to this intimate space where we make connections. There are connections we make as dancers on stage, with our dance partners, with the audience, and the chemistry with a photographer feels equally transformative.

MARIA-HELENA:

I knew I would miss this world when I stopped dancing: the smell of the theatre, the music, the chatter behind the scenes. My favourite moments as a dancer at Staatsoper Berlin were in the studio and backstage. I don't know the other side of the proscenium arch. I loved ballet, I was a fanatic. I gave my entire body and soul to it. When I was injured, my world crumbled. I remember lying on the side of the stage and thinking 'I will miss this'. Not just the dancing but the world of the theatre. I took up a camera at that point and learnt through practice. My father is an artist and I observed his world of cutting and framing. The camera became my form of armour, it protected me from everyone. Ballet can be a form of armour too. As it is for a lot of entertainers, ballet can be a lonely place. If you really see Nela, you can see sensitivity and sadness as well as laughter.

MARIANELA:

I am devoted to this art. I feel compelled to dance, it's like a spiritual necessity. I love being on stage. I can get lost in stories, in the music, with so many feelings that are hard to articulate. It's a place where I can free myself. Ballet holds me. In life's greatest moments and in the dark times, ballet is there for me. When one may be struggling or over-thinking, the stage provides a means of escape.

MARIA-HELENA:

Nela has the body of the best dancer in the world. Her body is very young. She relies on this instrument and takes care of it. One of her unique qualities is her complete physical control. Her physical movement expresses what words cannot. And combined with this powerful physicality, there is vulnerability. Ballet photography can be a boastful space for perfect bodies and athletic wizardry. Nela transmits something very human on stage to an audience of over 2,000 people, a place for us to dream, love and hope. I'm always struck by this humanity that she brings to all her roles. This is the beauty to be captured. The pandemic came as a reminder of what our lives would be without art; without it, the breath is taken away.

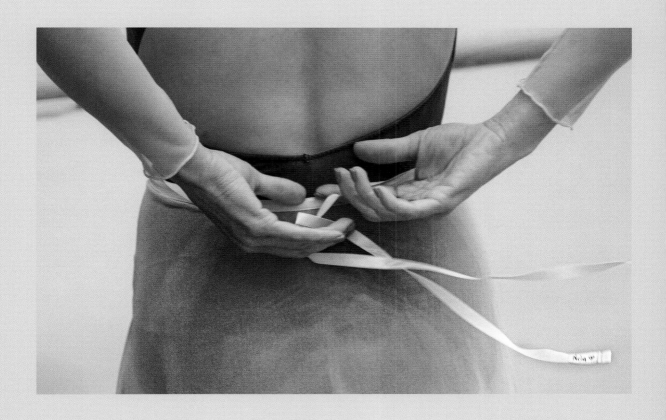

The bouquets on stage are exhilarating but a life in dance is not a bed of roses. We work hard, our energy waxes and wanes, we keep on trying, we keep on reaching.

MARIANELA:

The aesthetic beauty of ballet never fails to fill me with awe. When I watch other dancers, I'm transfixed by the beauty they create. I hear them talking about ballet as I do, I watch them move, I see the respect they share for this artform, and it becomes this fantastic collective endeavour. We aspire to bring our true selves to this form of expression, to approach it with integrity and authenticity. It's difficult to describe but dance is definitely a connection to something higher, to the sublime. When it takes you to another place, it enriches and transforms.

MARIA-HELENA:

Photographing Nela is like being in a special bubble. The focus is intense. You can see everything. Artistically, Nela embodies the complete perfection of illusion.

MARIANELA:

In the studio, it's like having so many ingredients to bring together, like having something in one's hands to mould. I'm hungry for everything to get closer to this special state that dance gives me. The nerves for a production start three weeks before my performances. I put a great weight of expectation upon myself. On the day of a show, I get ready early. It's a rollercoaster of emotion but I know I've put all the work in. I accept all the emotions, all the questions and doubts; they're all part of the process. On stage before the performance, I like to look around at the lights. I take it all in. And breathe. The audience is like a magnet, I feel drawn to them. Some nights are electrifying and I can really sense the audience. You can't see them but you can feel this palpable energy from the other side of the proscenium.

MARIA-HELENA:

I still find it strange to call myself a photographer. Inside I remain a dancer. I prepare a lot for shooting. I think about the dancer, about the choreography. A strength is that I know bodies and technically I know how they work, how they prepare for a jump, the speed of preparation, the moment of take-off. When it comes to the day itself it's easy to get carried away with Nela, to watch in awe and forget to snap. When I'm in the flow, I feel as though I'm dancing with her. Photography for me has to have meaning. It's also about respect. I'm here to serve the ballet, the movement; my ego is not important.

MARIANELA:

After reaching for these ecstatic moments of performance, it's always back to basics in the morning. Back to the barre, back to rehearsal. The process is as precious as the production. We're always polishing, more and more.

MARIA-HELENA:

Maybe the secret to Nela's distinctive presence is her honesty – her complete honesty with her work, with her friends – and her celebrated quality of being respectful to everyone, from choreographers and designers to all the Royal Opera House staff behind the scenes and her fans waiting at stage door. She is an inspiration to so many young people.

MARIANELA:

For young dancers starting out, I'd urge students to work on self-acceptance. Strive for continuous learning, strive for ongoing discovery, practise self-acceptance. Let's acknowledge our vulnerabilities. It's ok not to be fine. Embrace your flaws. And we should remember that there are no shortcuts in this business. In these times when life moves so quickly, we have to pause, to work, to graft. The bouquets on stage are exhilarating but a life in dance is not a bed of roses. We work hard, our energy waxes and wanes, we keep on trying, we keep on reaching.

MARIA-HELENA:

I find Nela so open when she dances, she leaves her soul on stage.

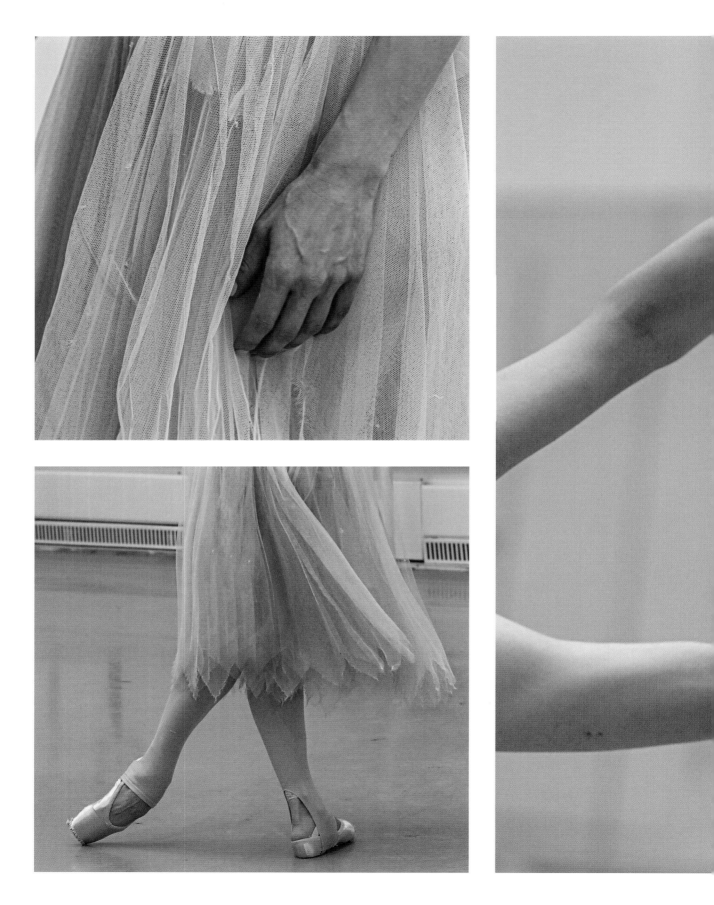

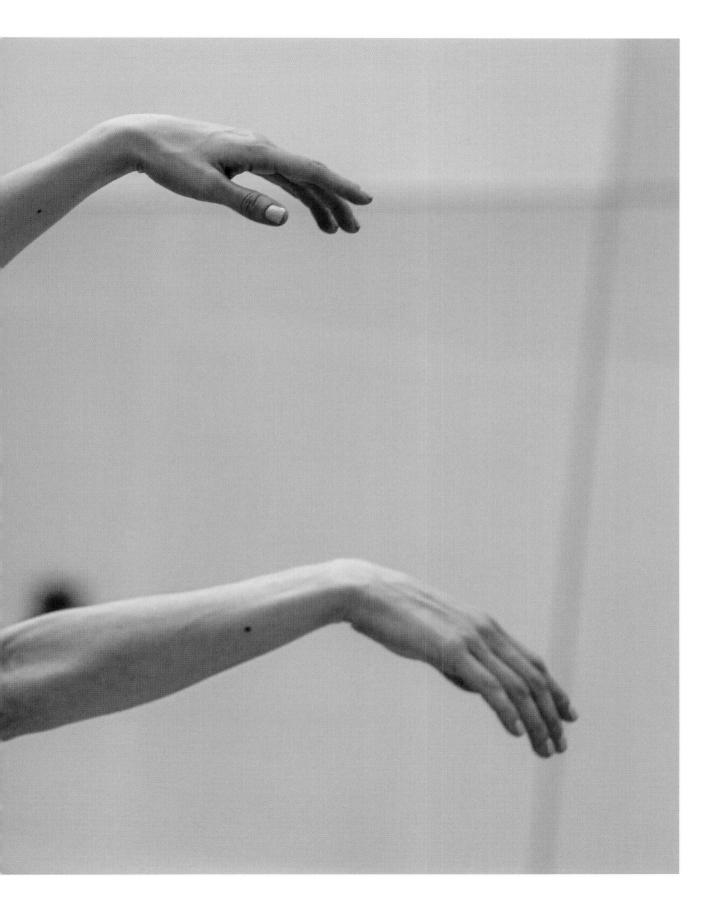

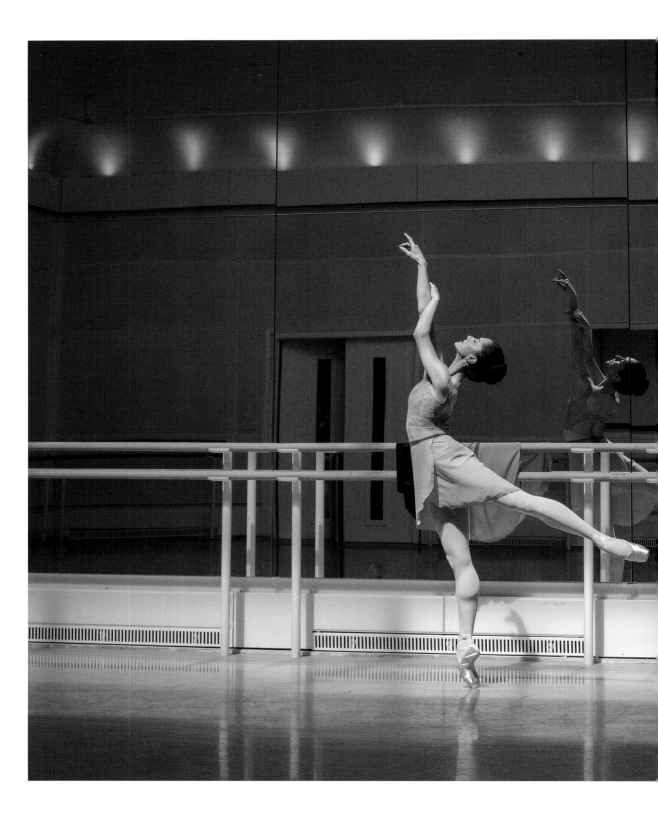

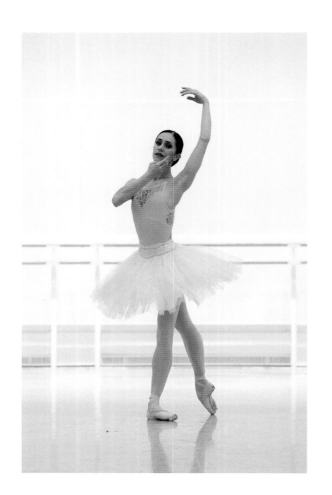
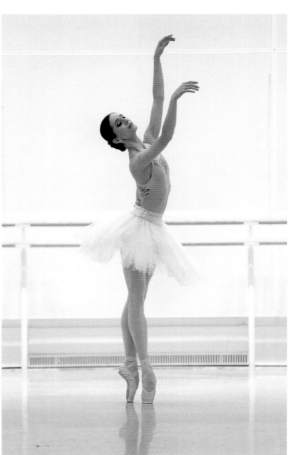

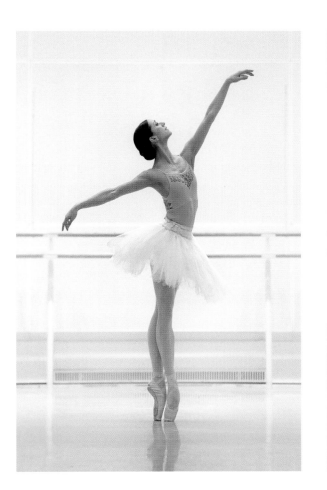
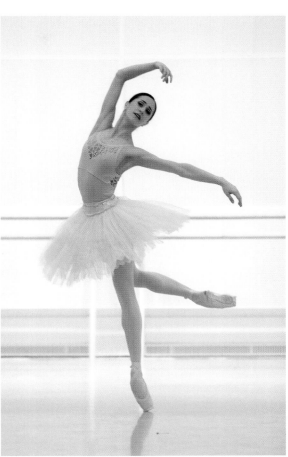

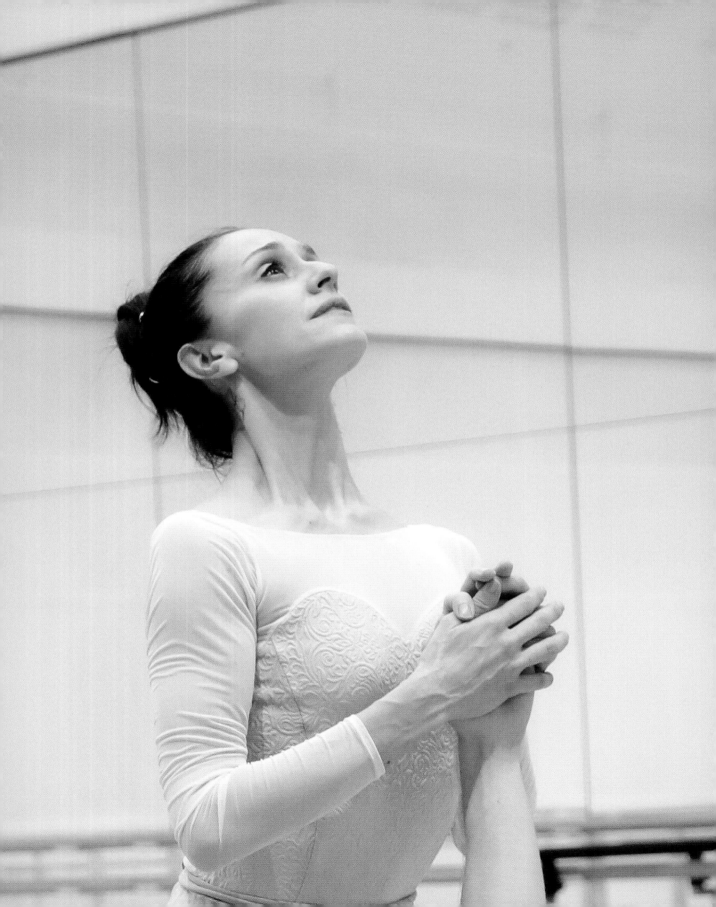

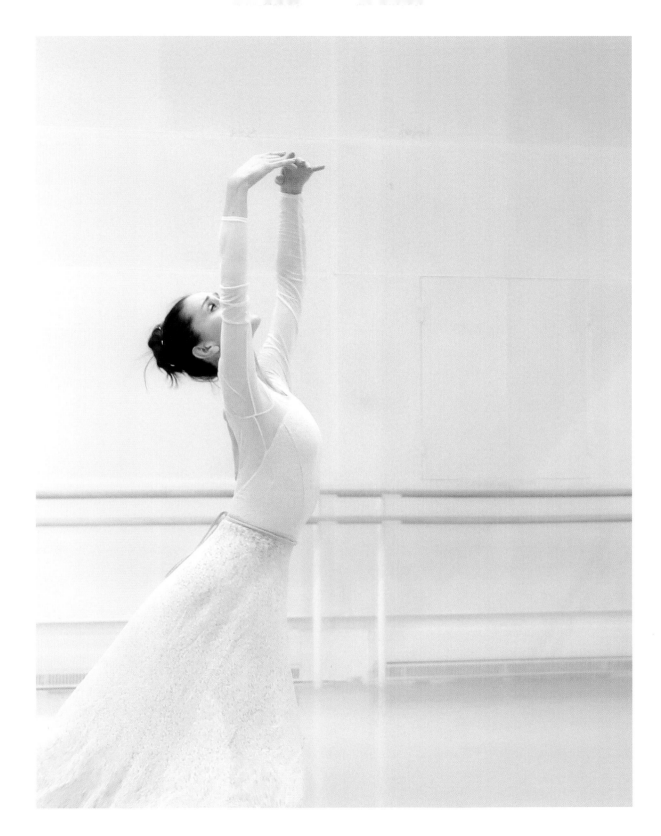

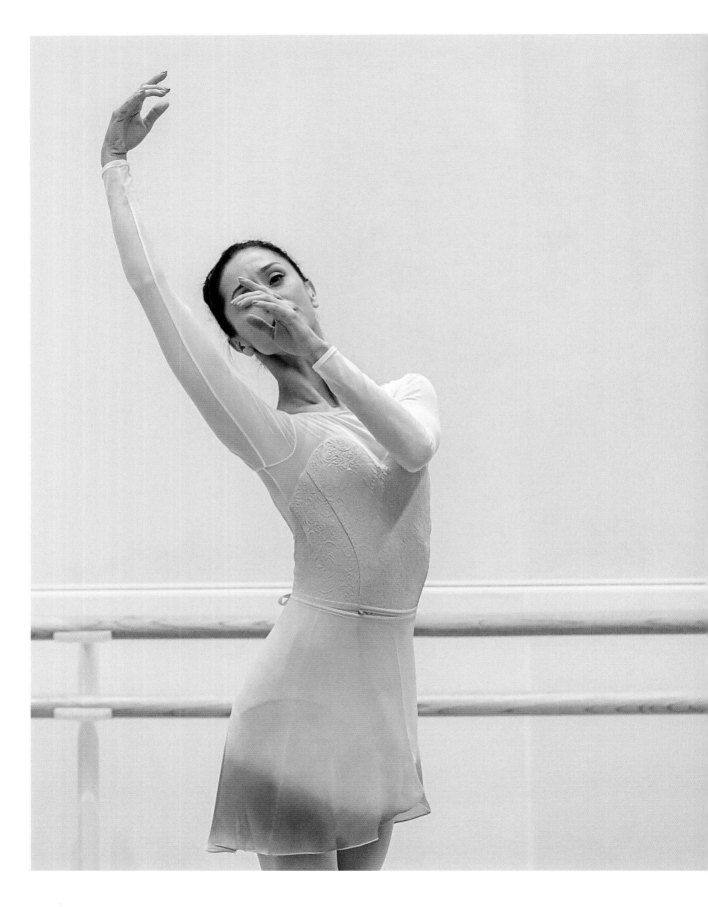

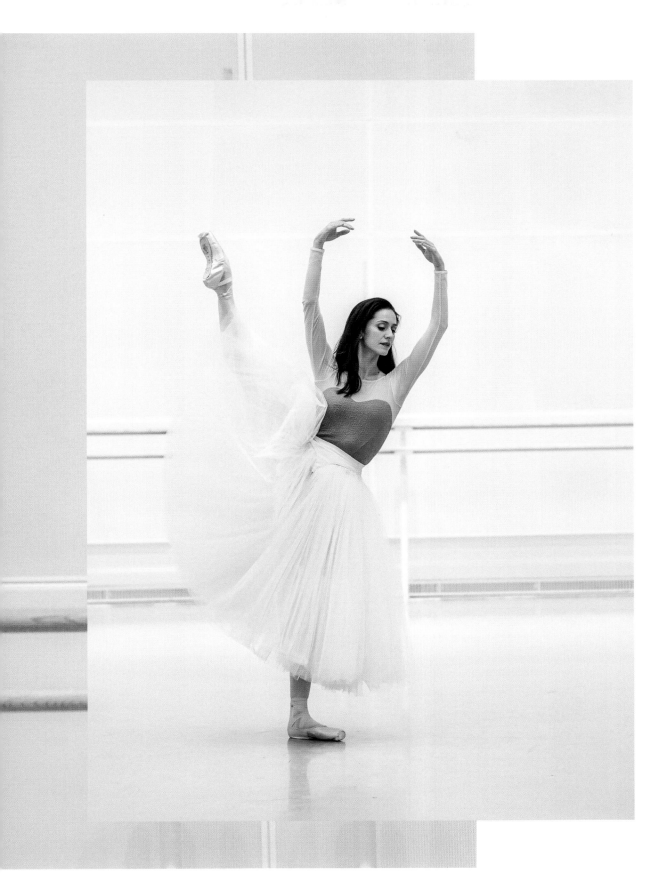

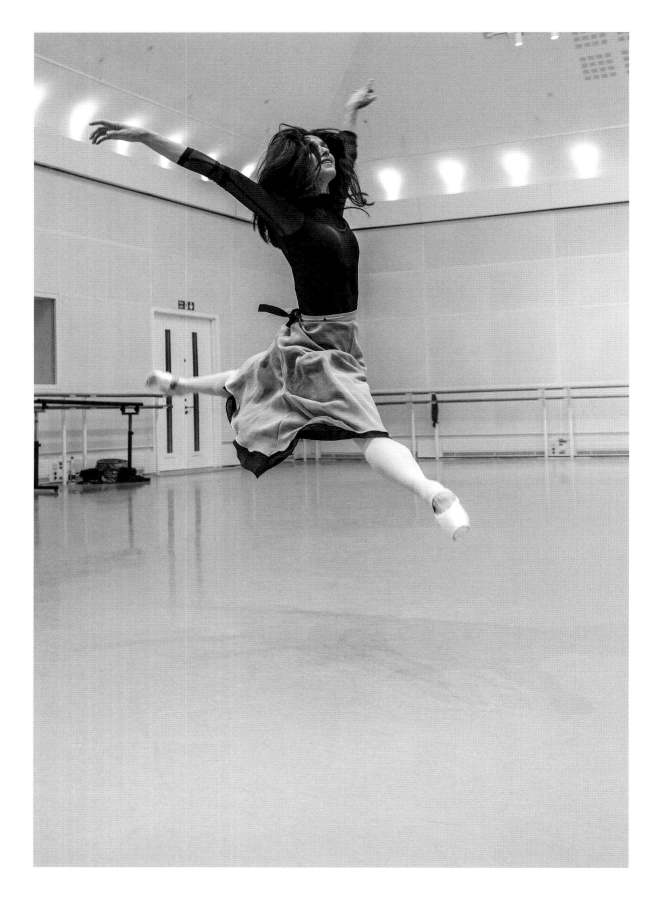

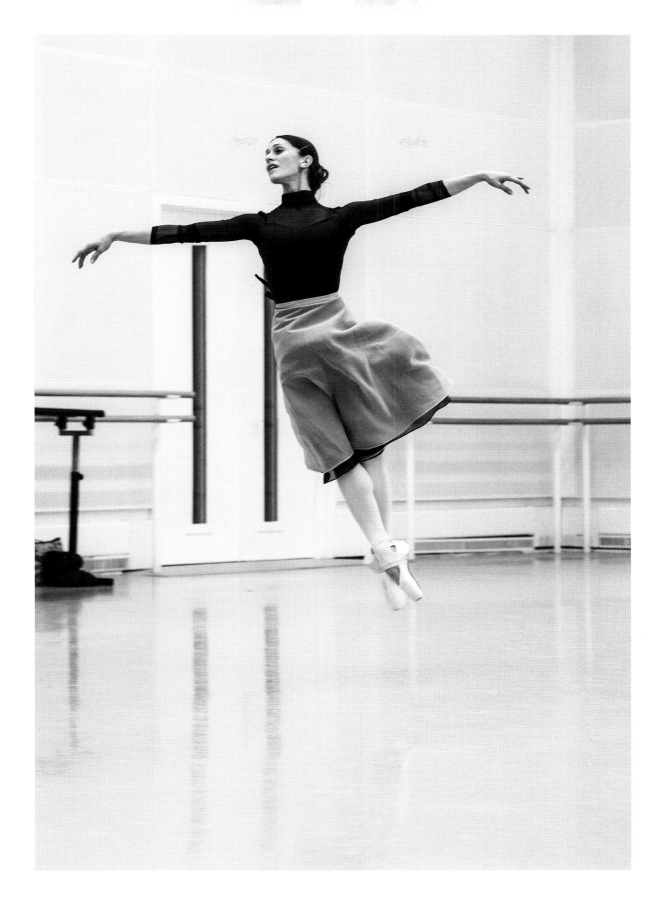

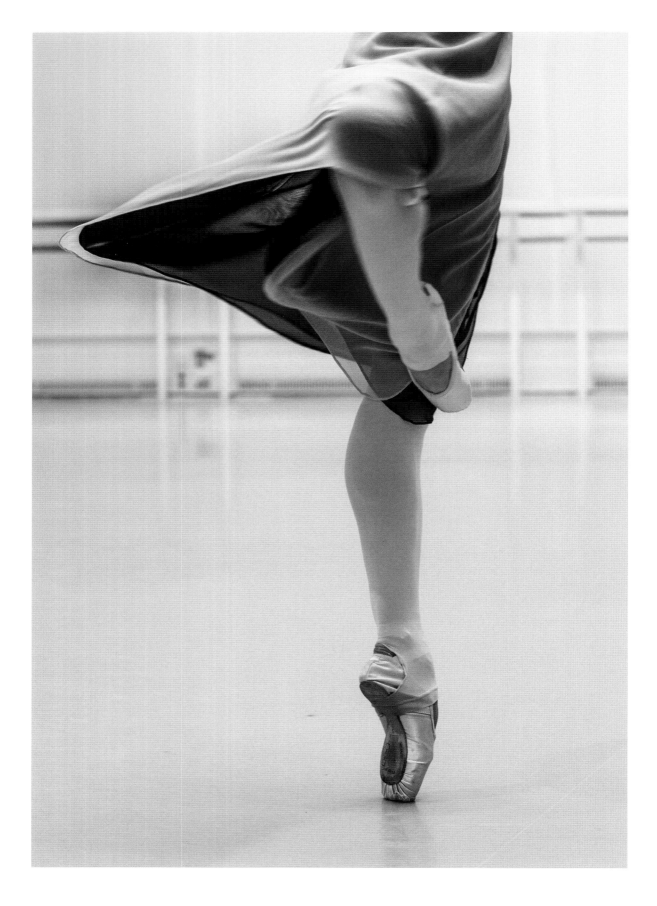

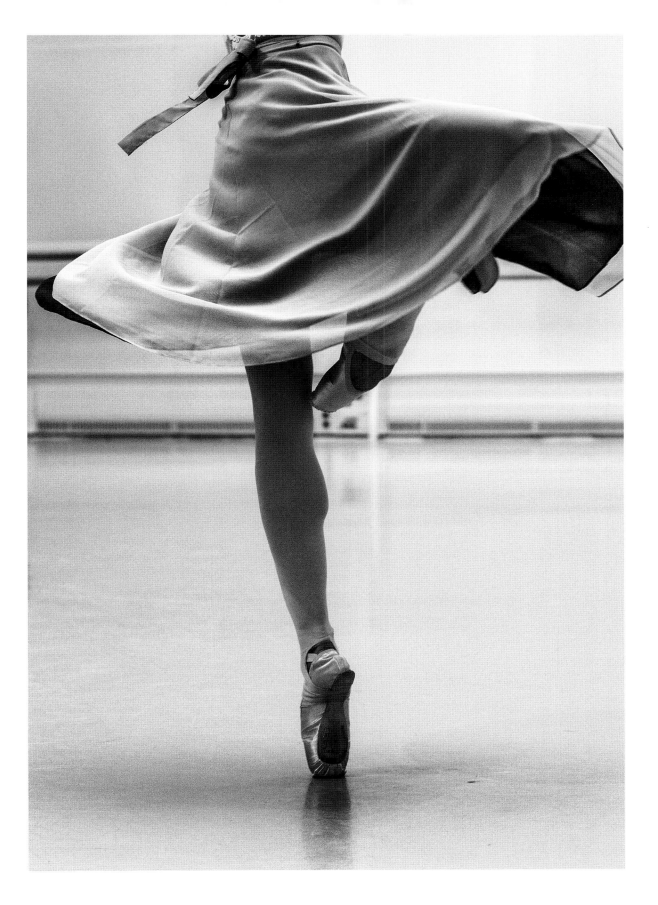

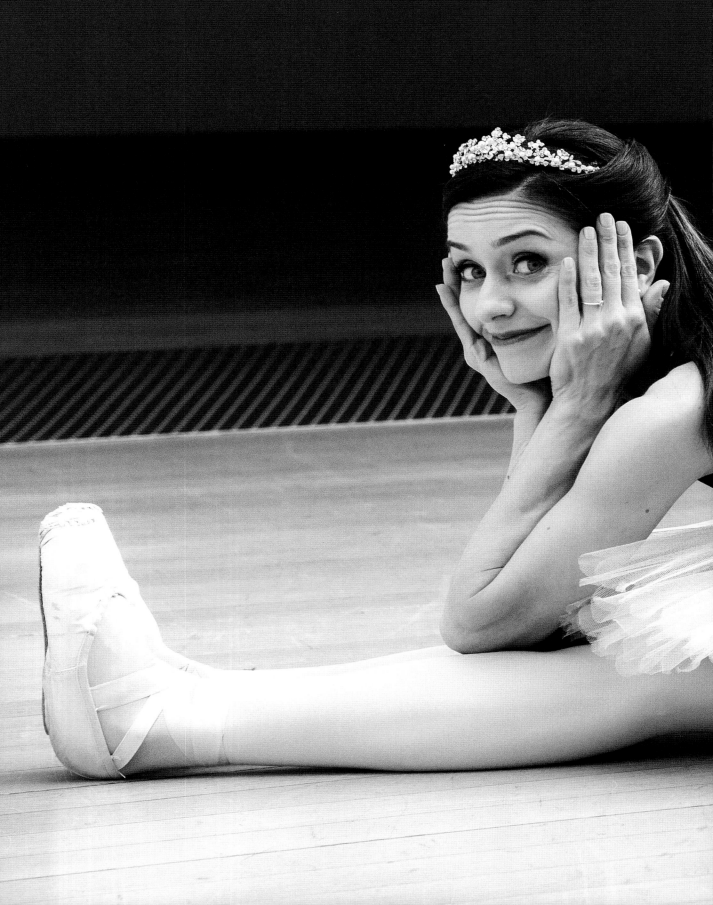

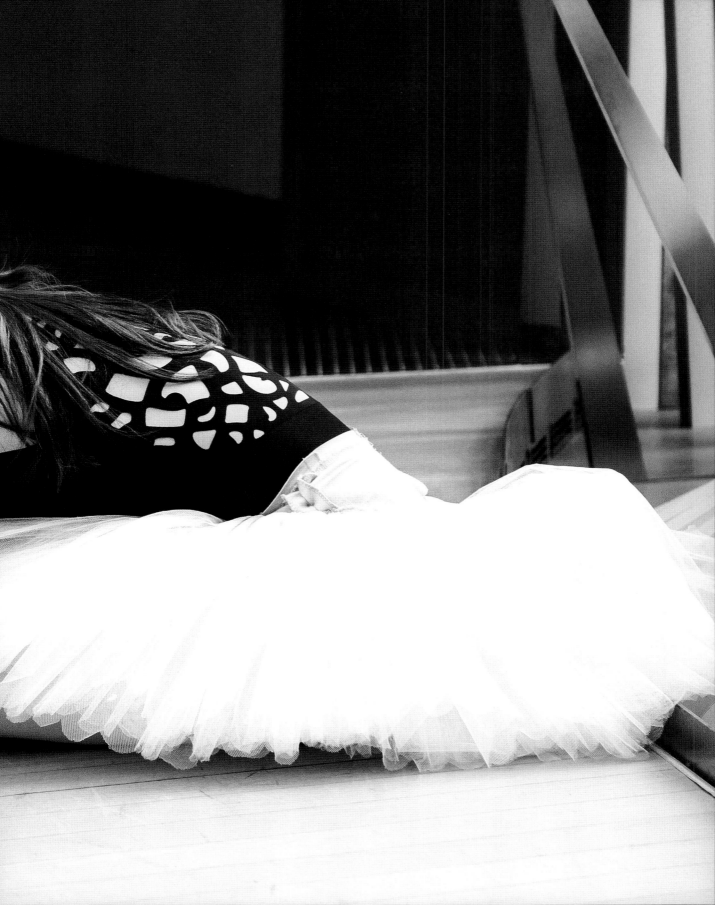

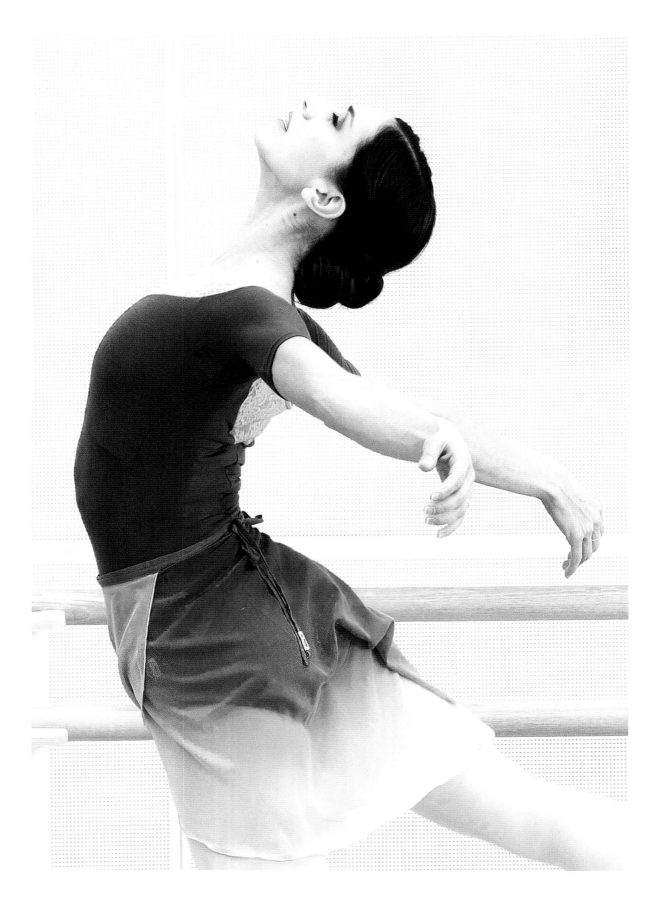

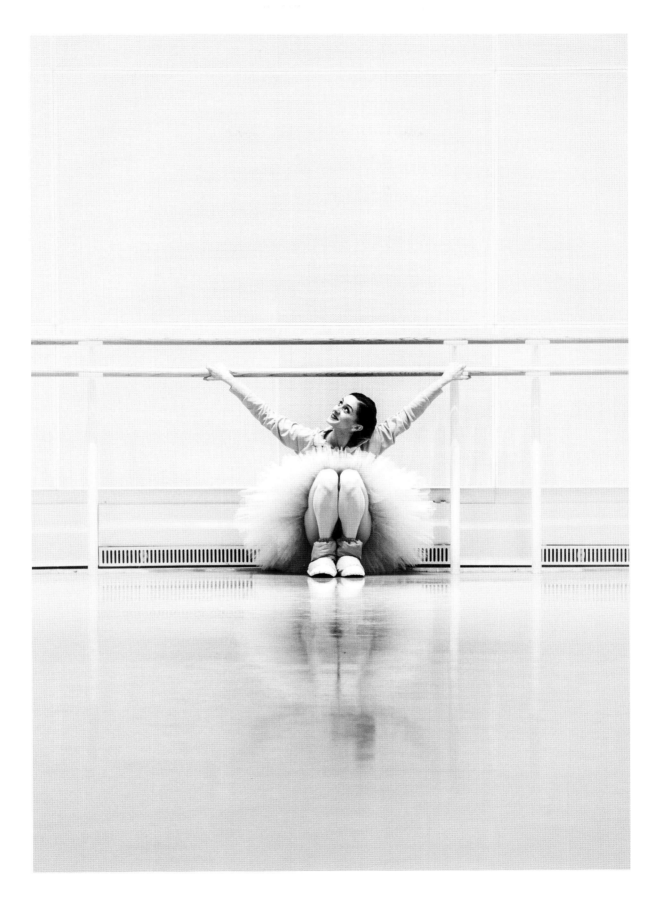

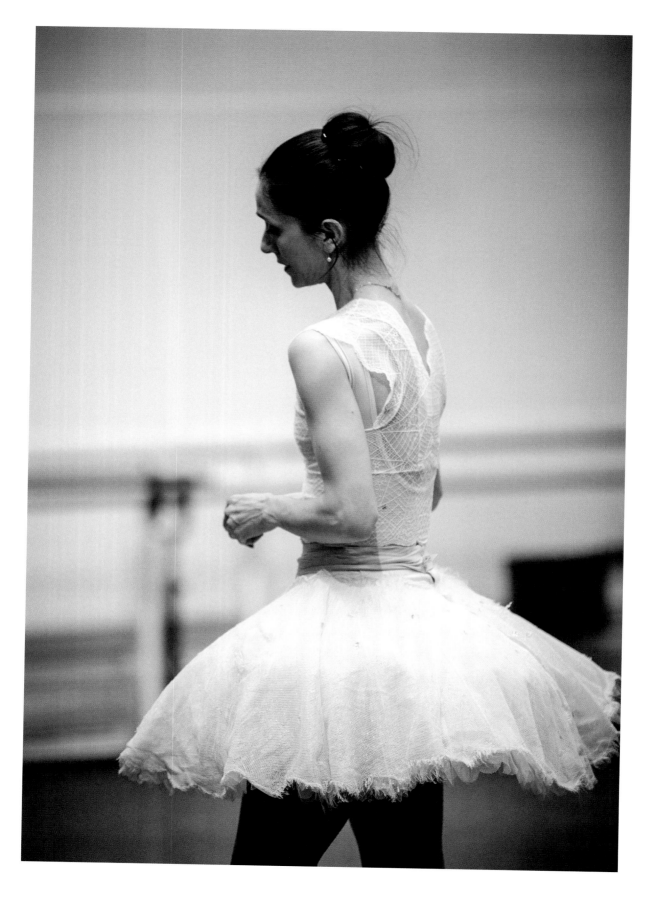

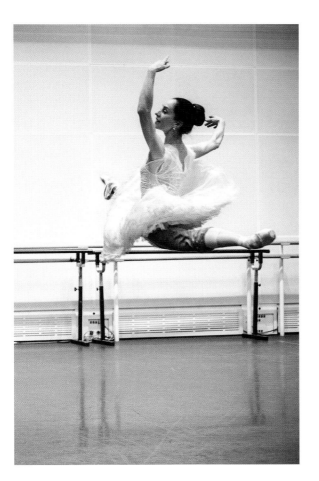
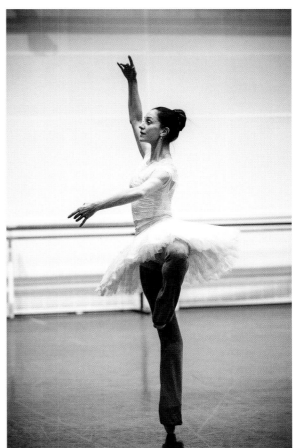

I am devoted to this art.

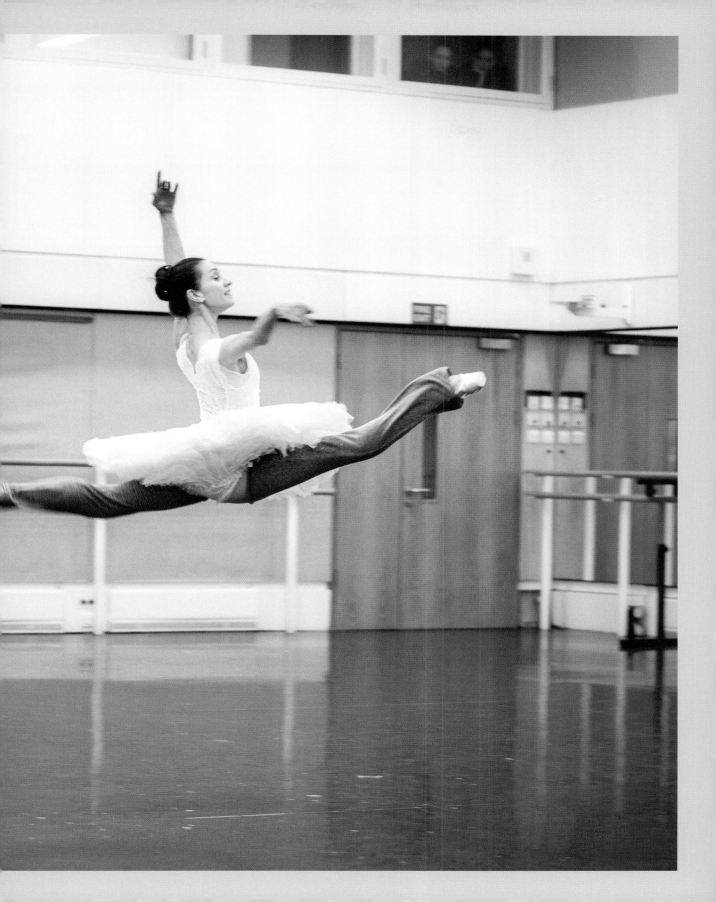

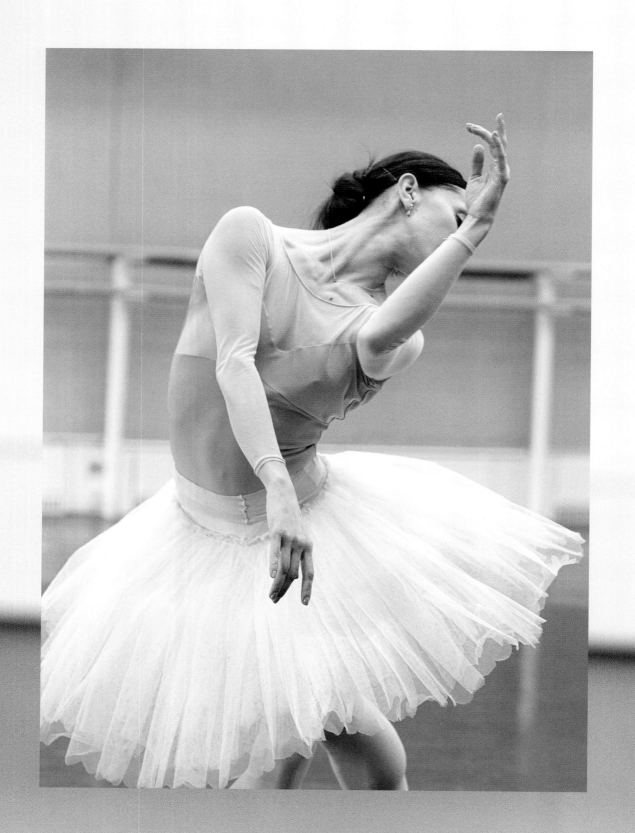

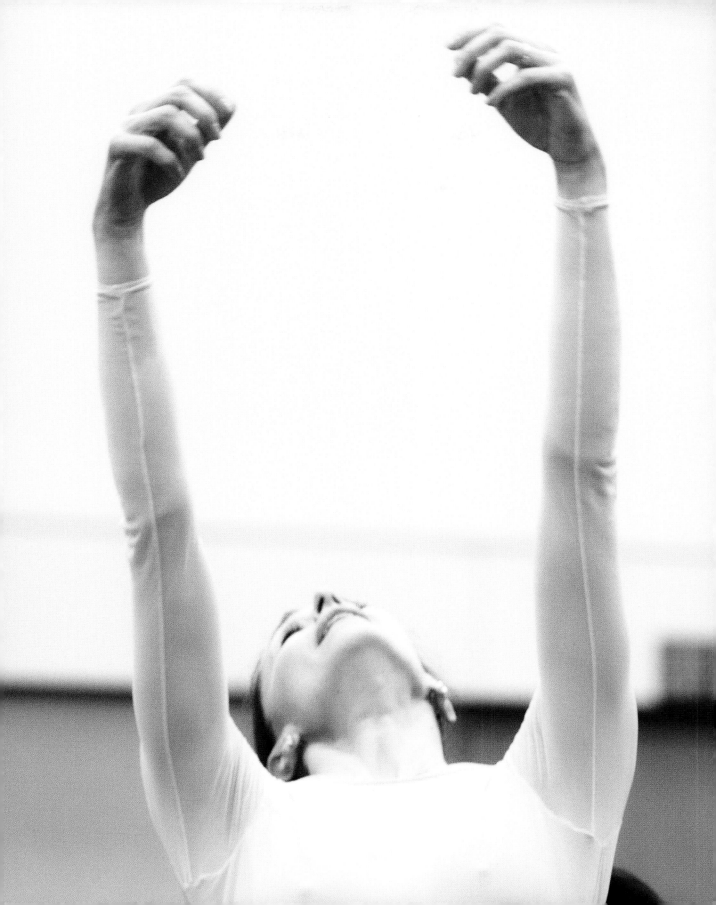

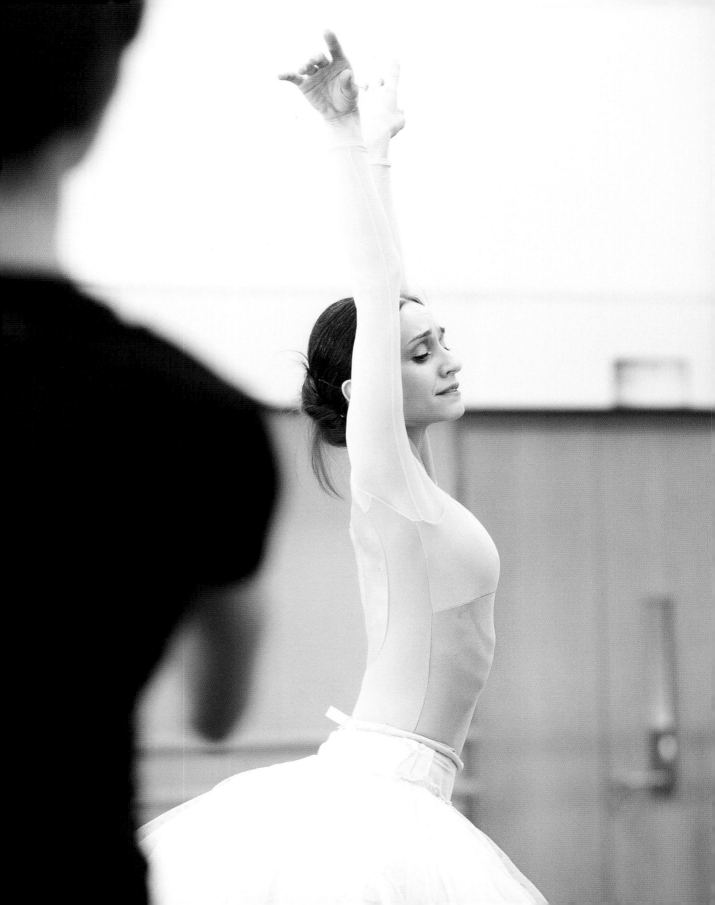

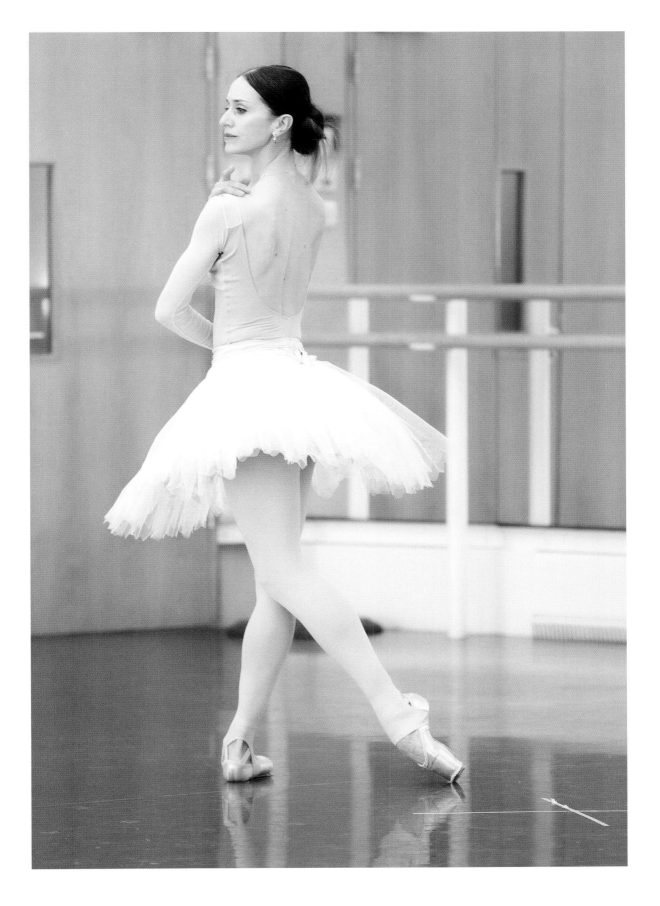

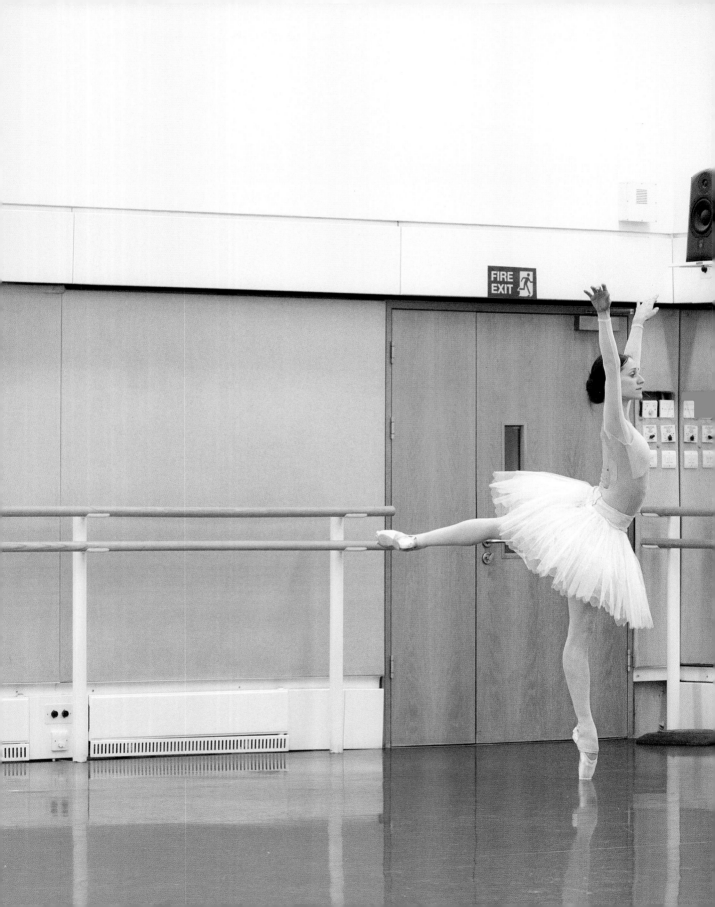

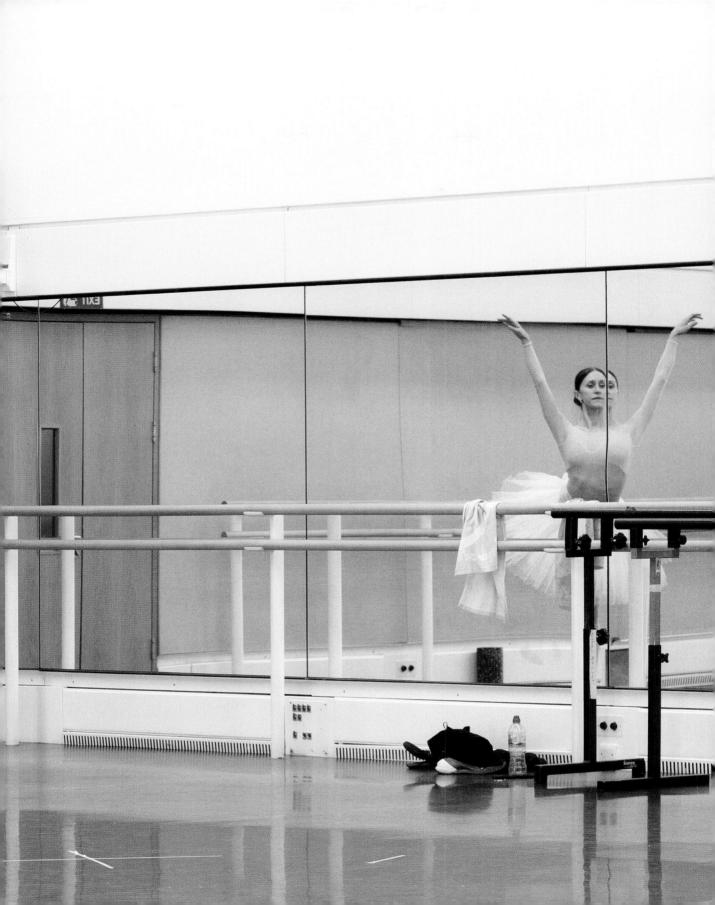

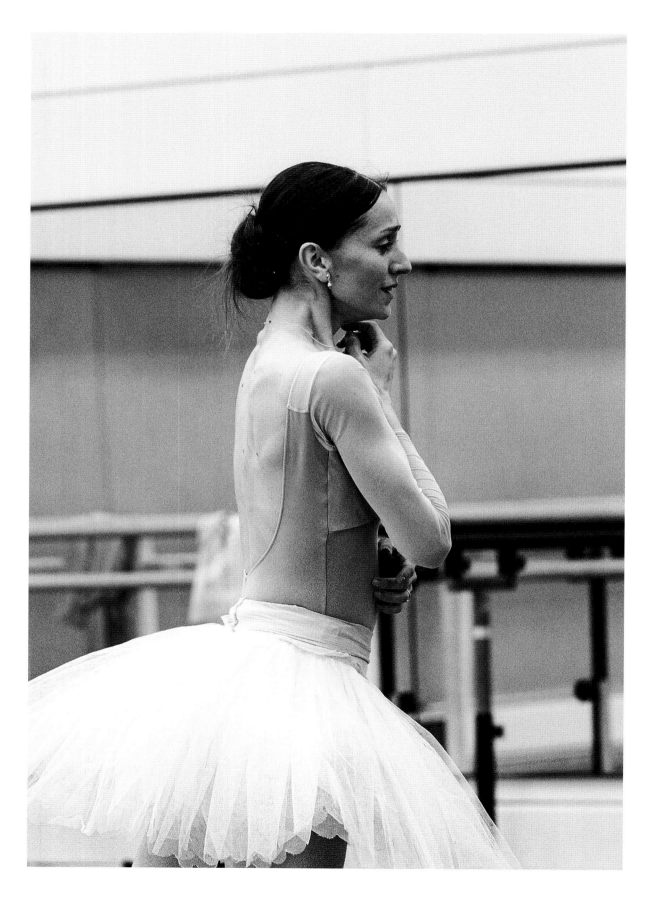

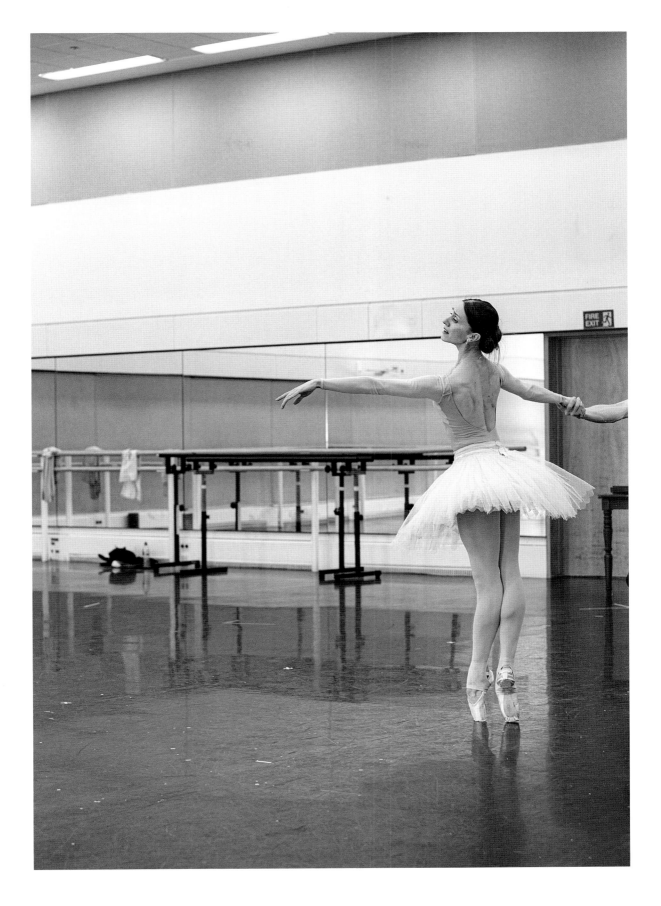

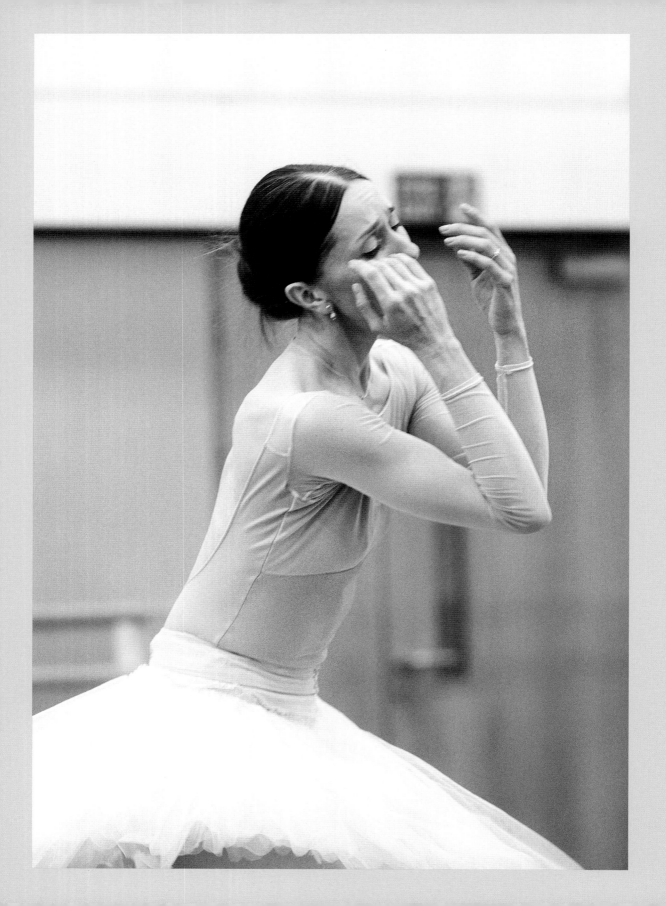

*I see Maria-Helena's photo and I can almost
feel the feathers and hear Tchaikovsky's music.
A whole moment comes to life and Odette
pours out her soul. The sadness is palpable.
Swan Lake is the pinnacle for a ballerina.
It's physically and dramatically draining, and
in order to perform this epic ballet you need
to fall in love with every aspect of Odette and
Odile. You need to be devoted to them both,
to the flaws and frailty of their dual character.*

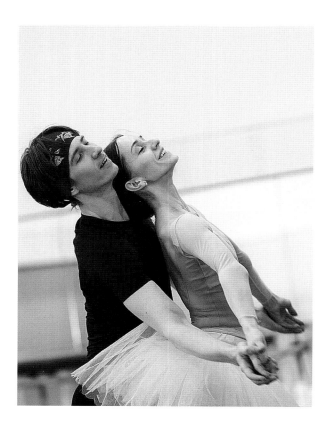
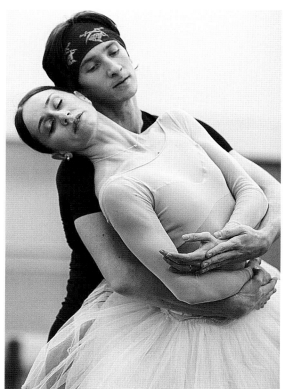

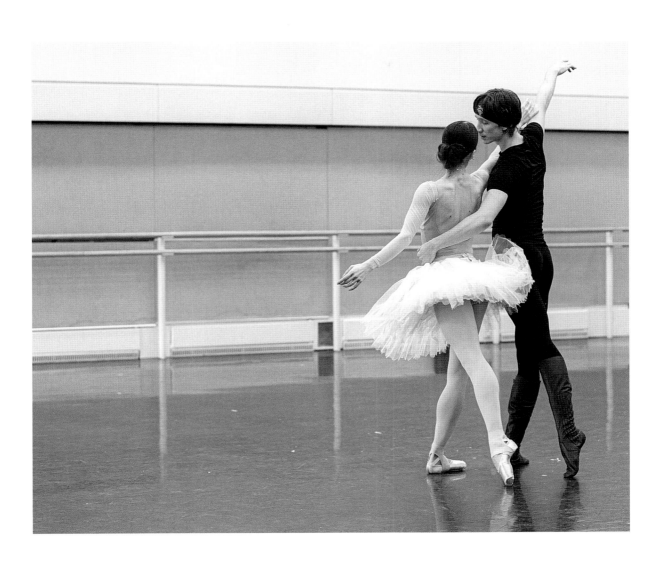

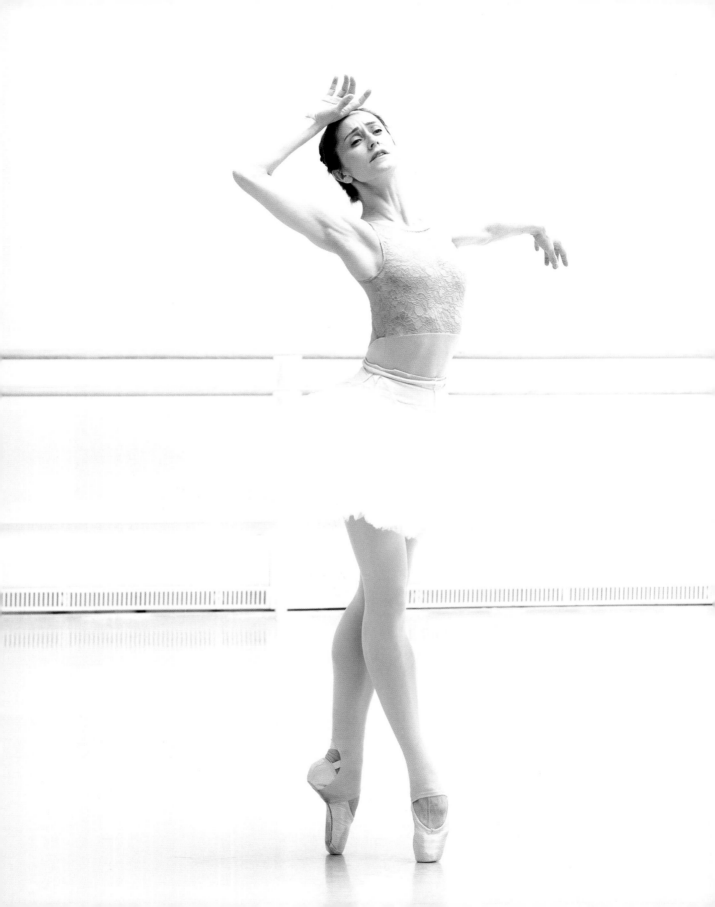

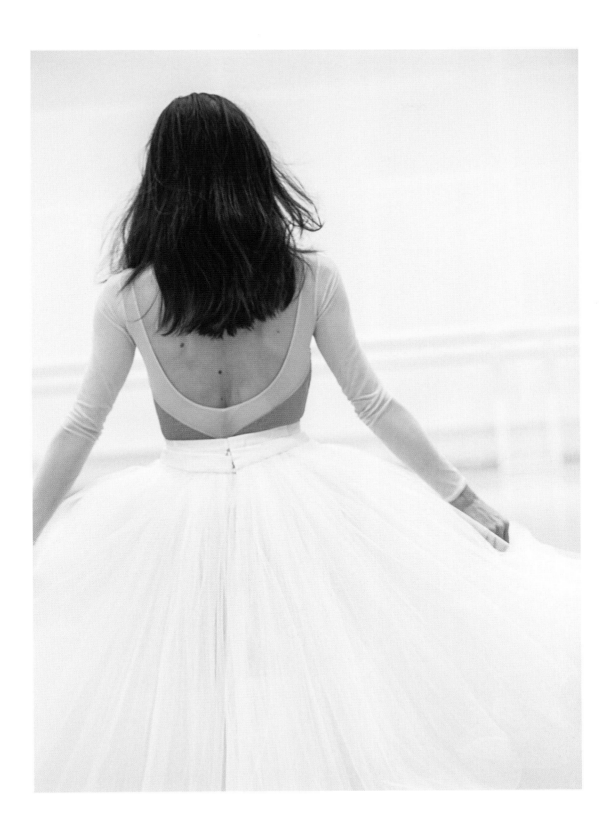

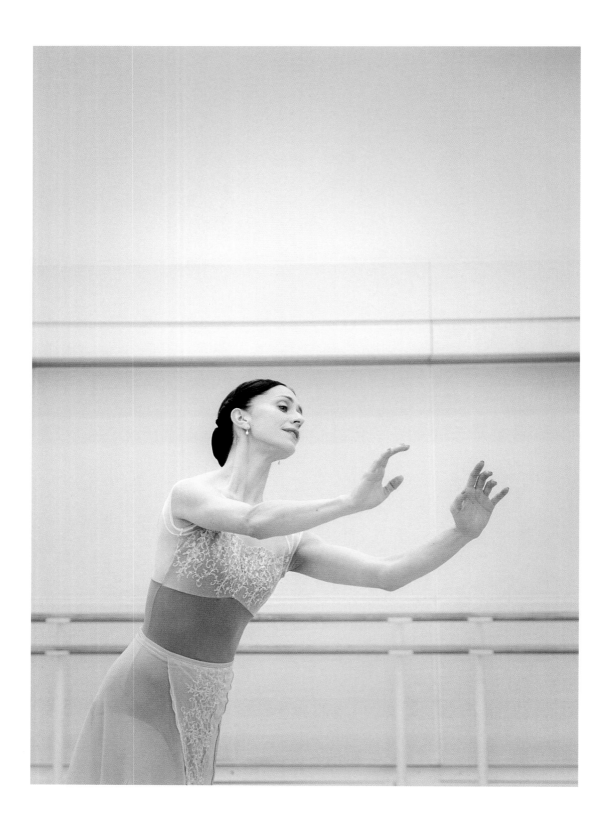

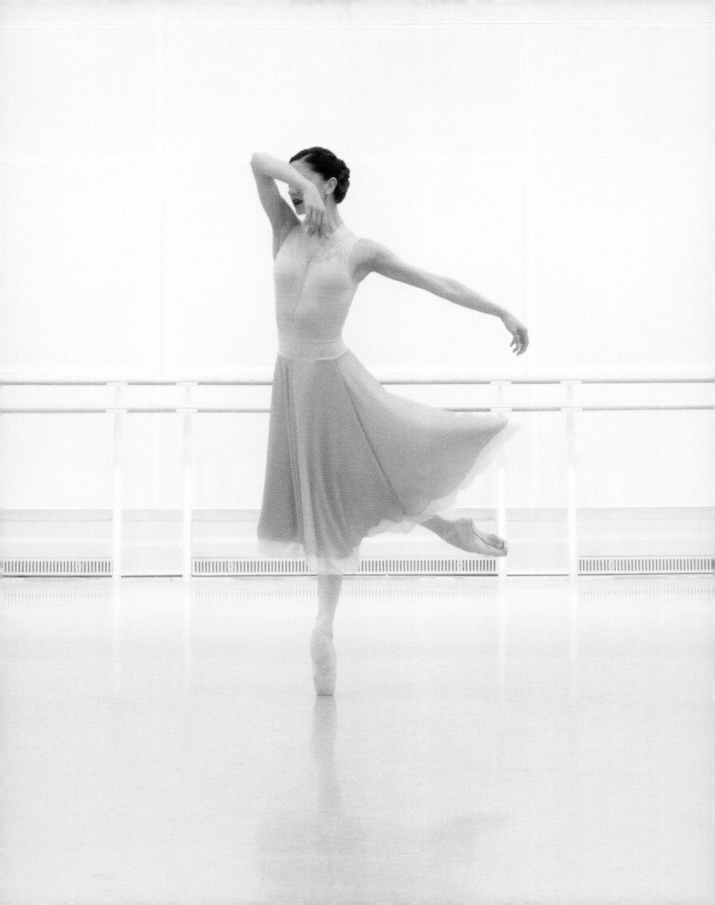

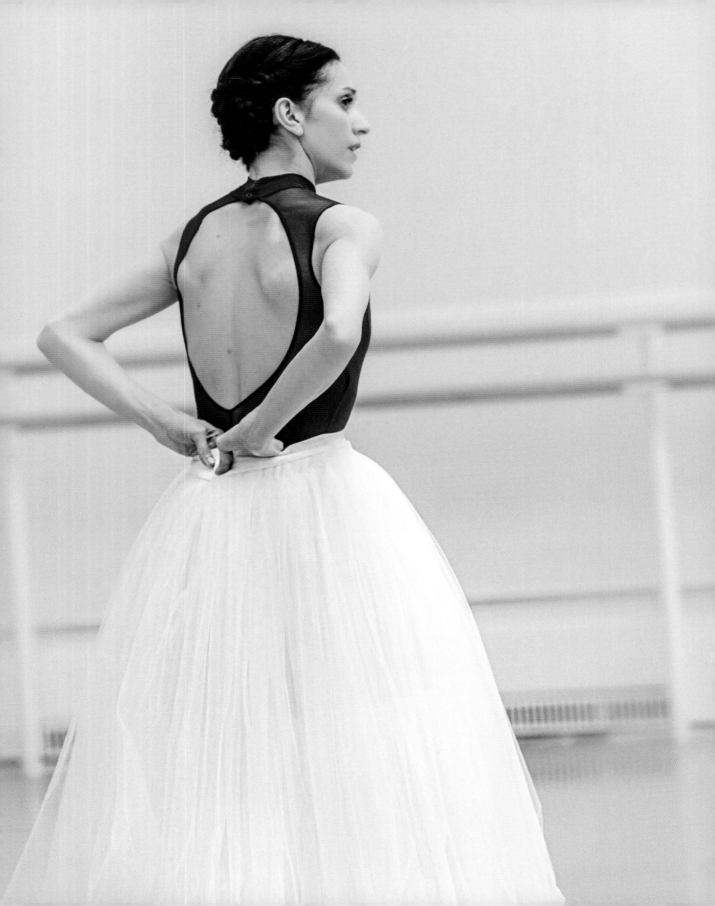

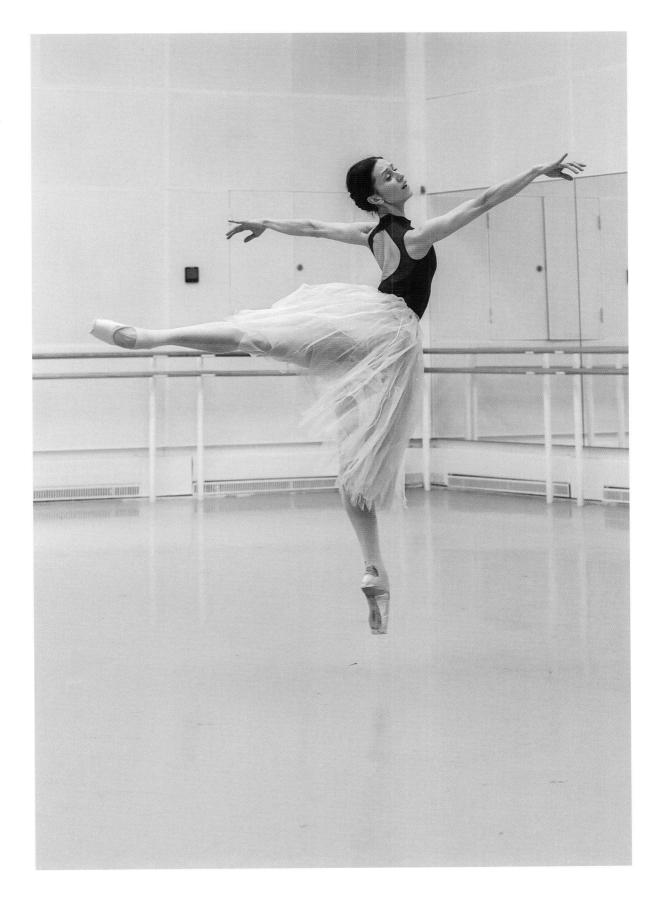

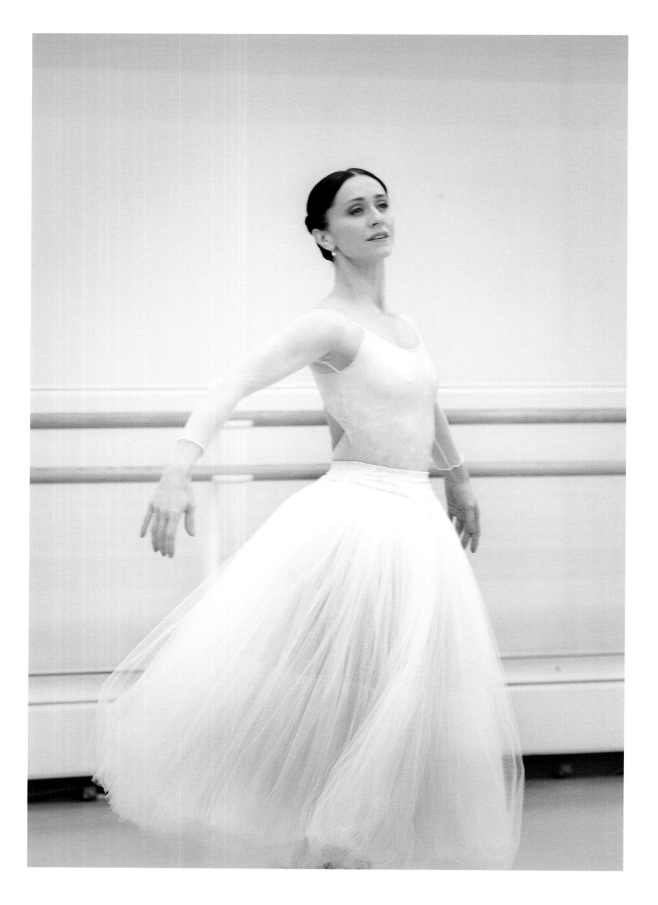

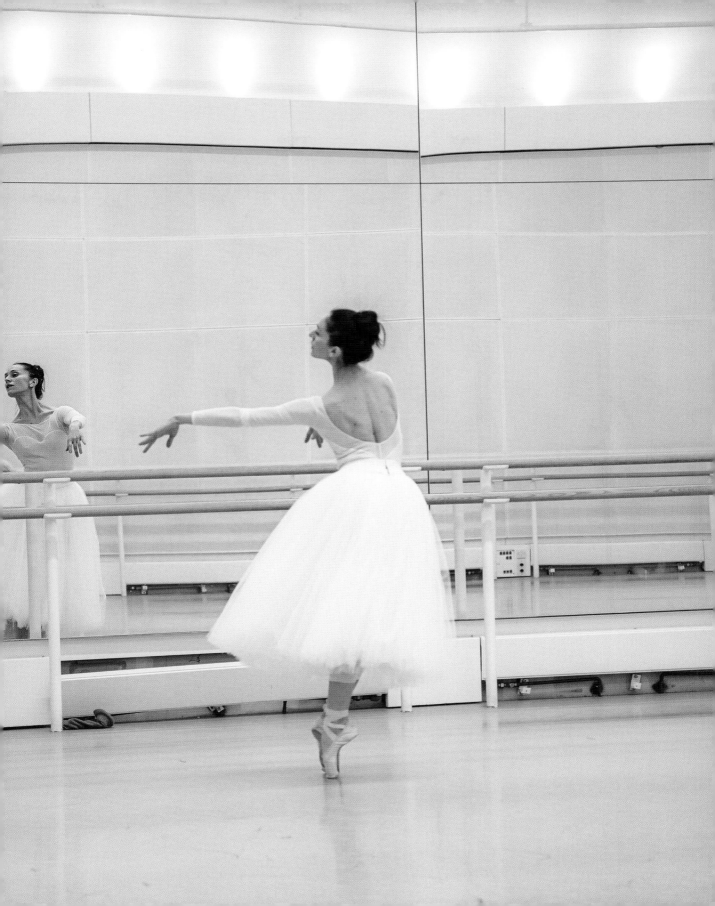

I always connect with Giselle, with her nature, in new ways. Her character emerges without force. The ballet is a hallowed space.

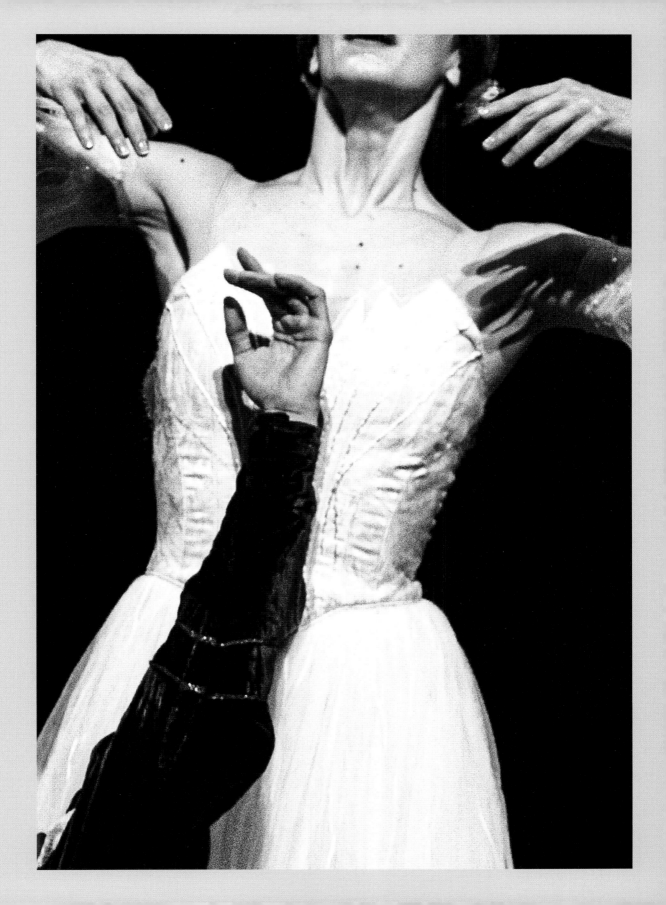

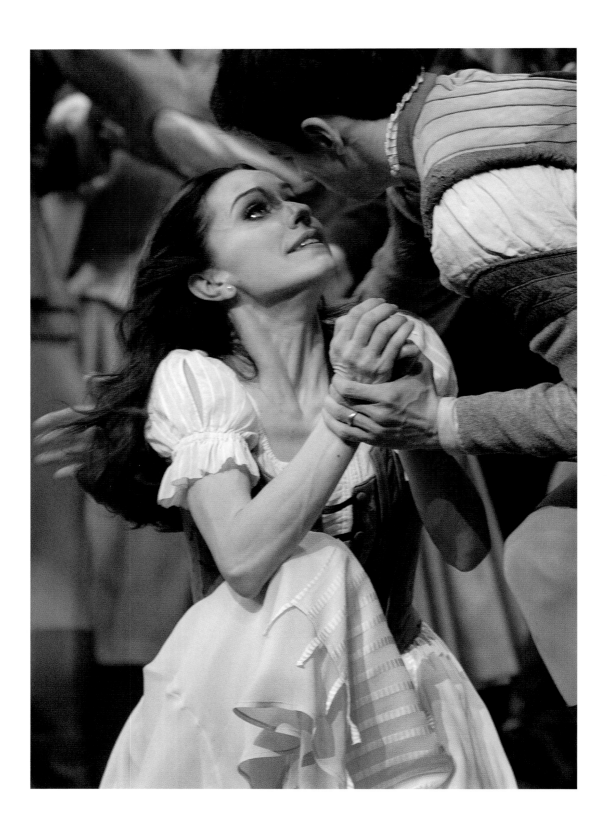

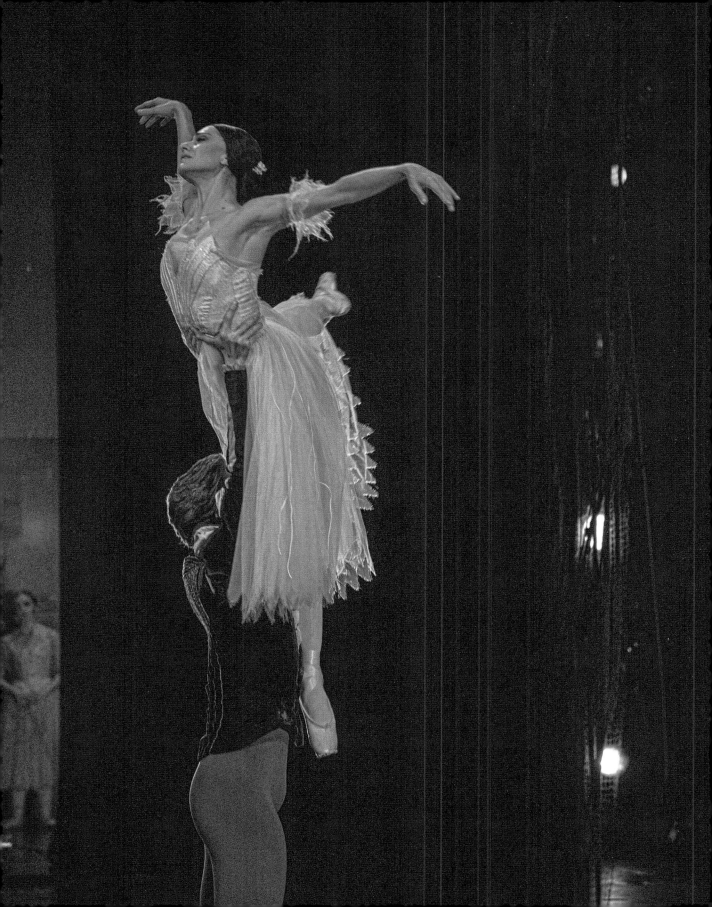

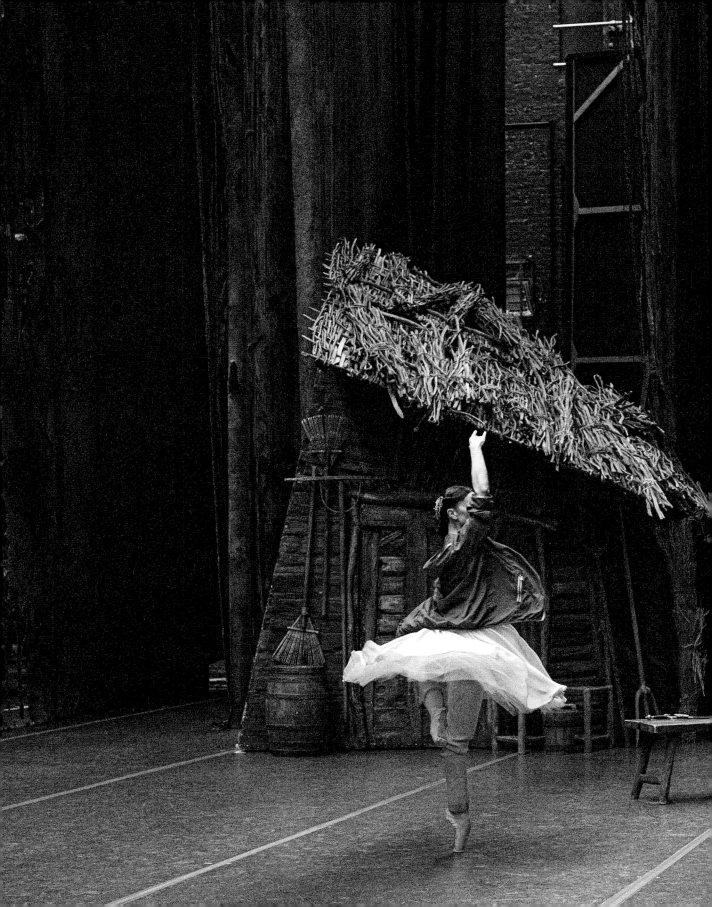

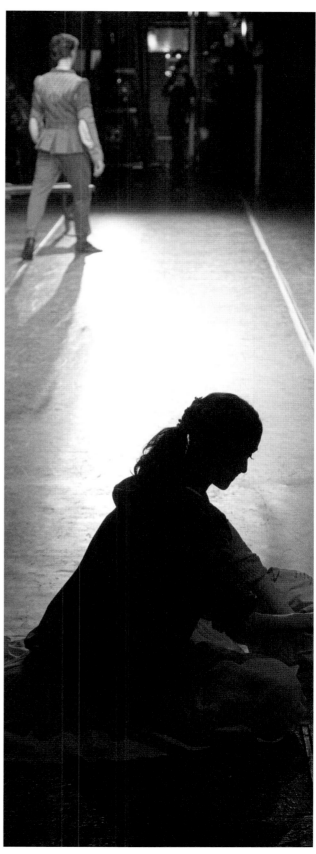

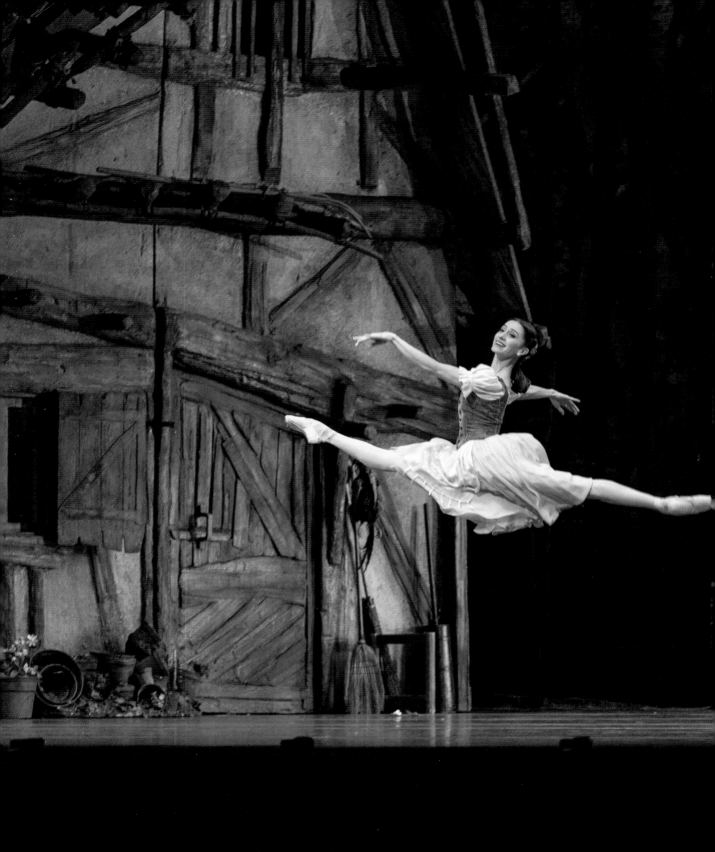

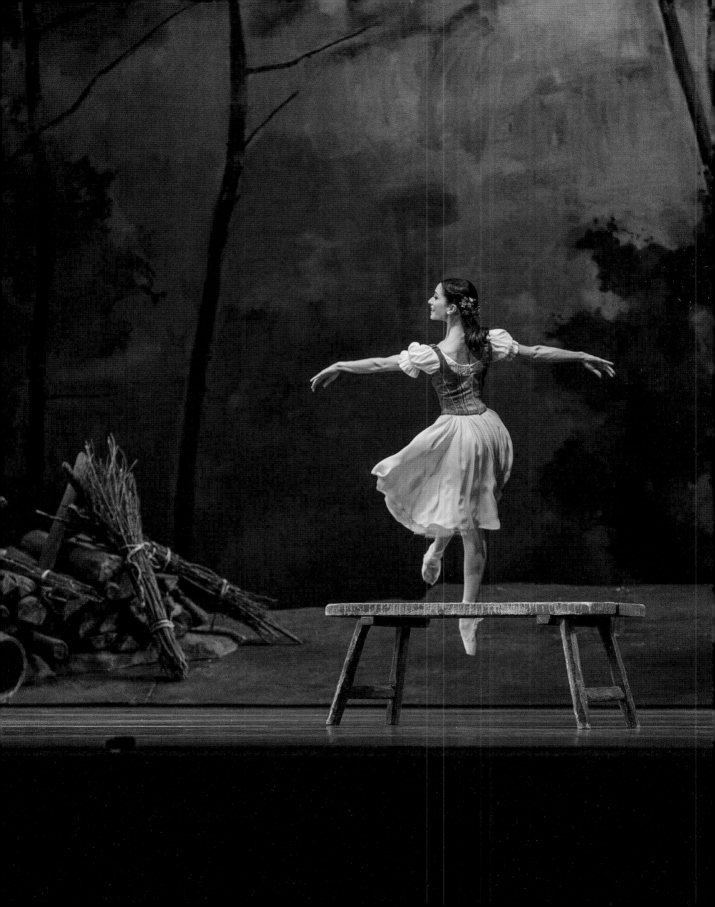

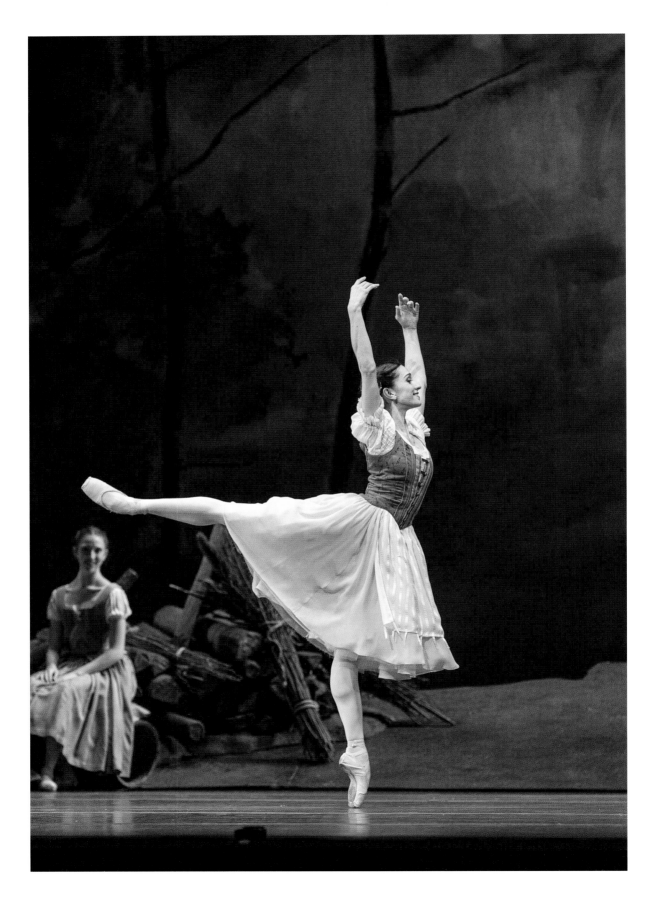

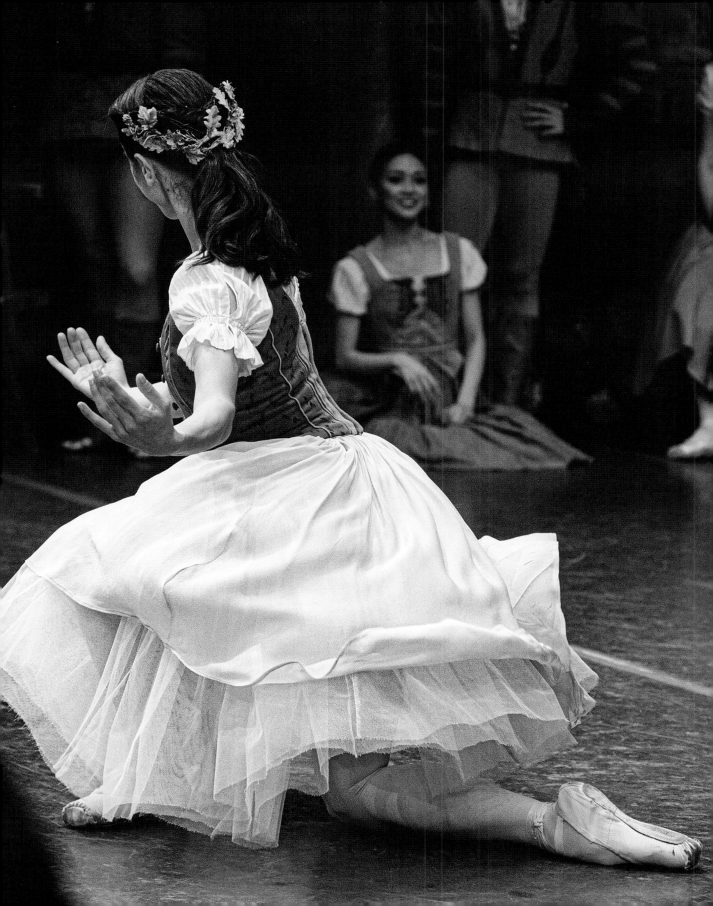

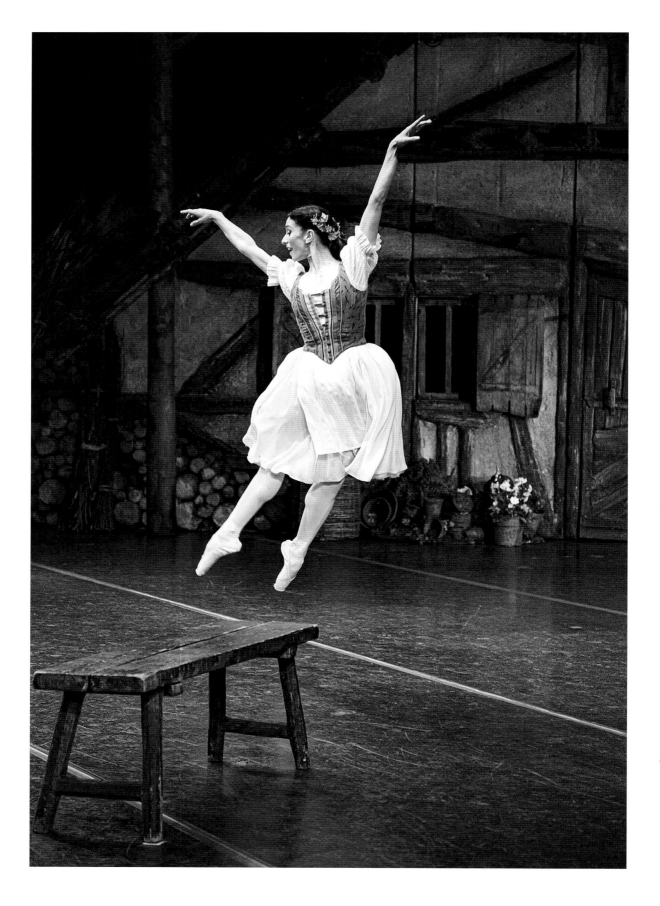

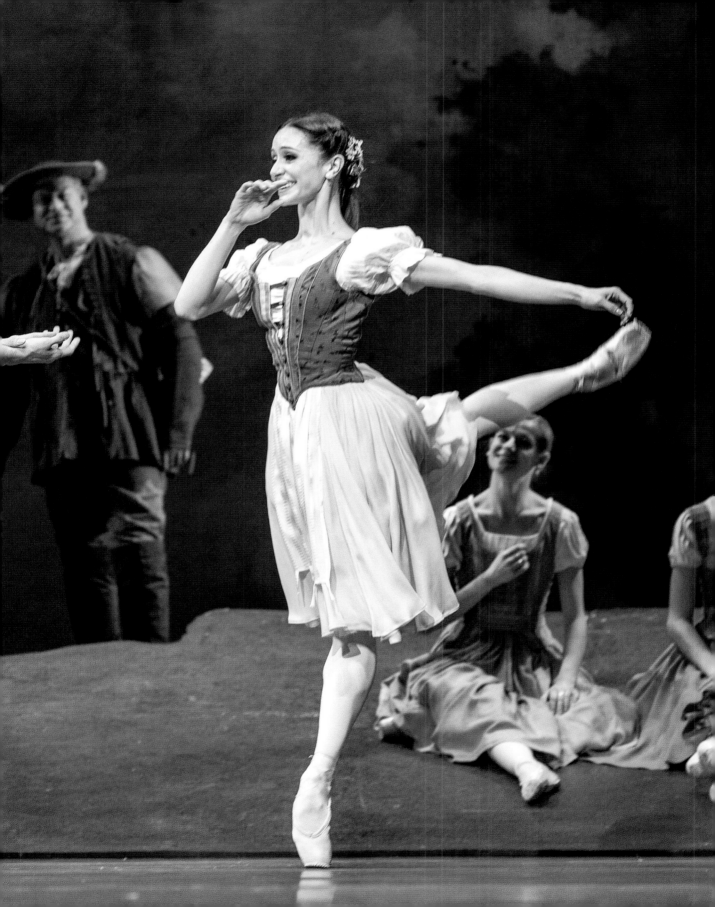

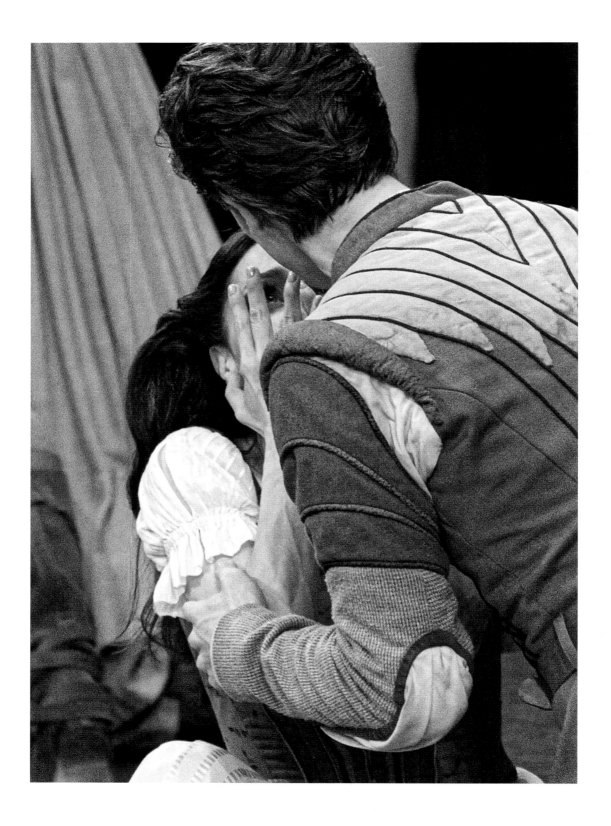

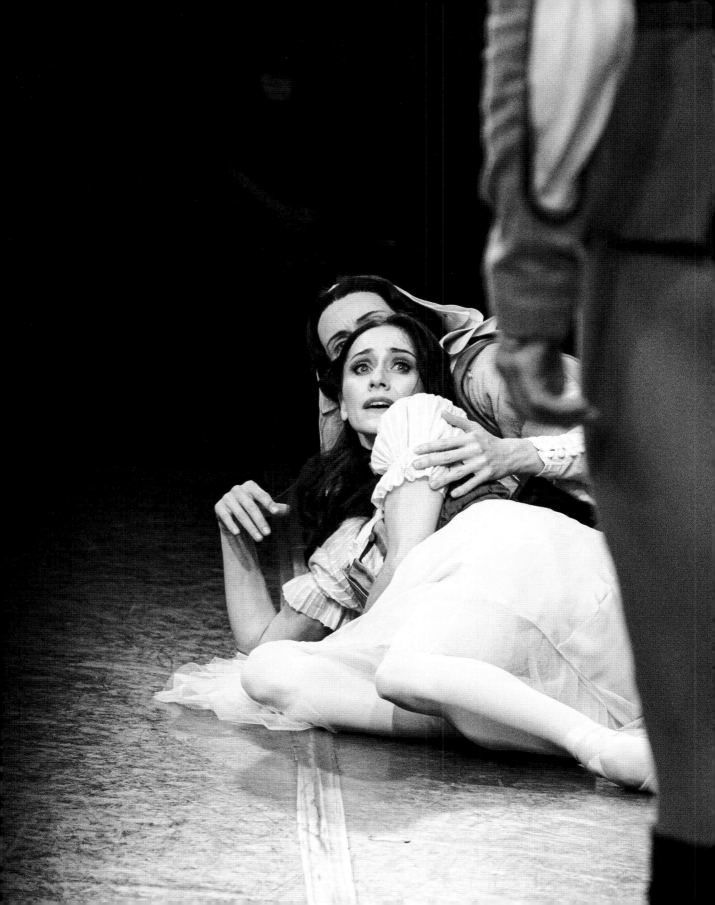

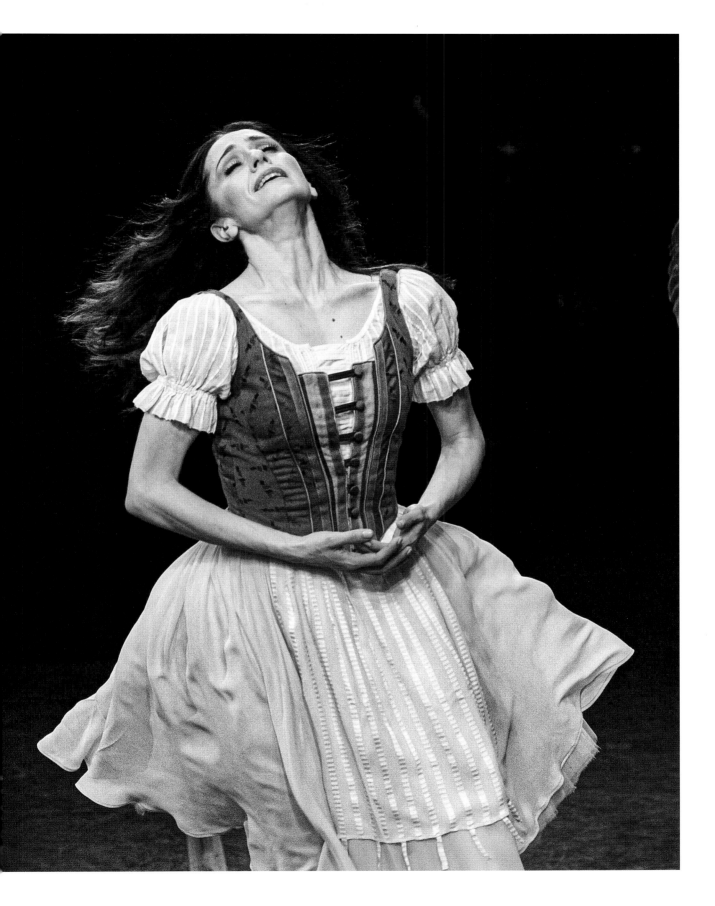

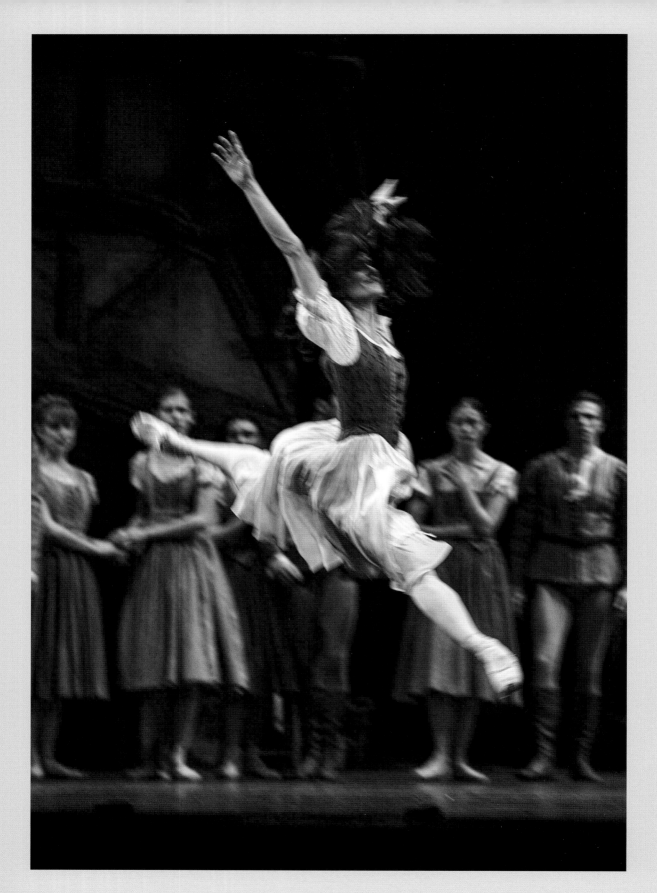

I'm often asked about what it is to dance. I can't describe it. What can't be set out in words is spoken through the body. What we can't describe in writing can be captured in a photograph.

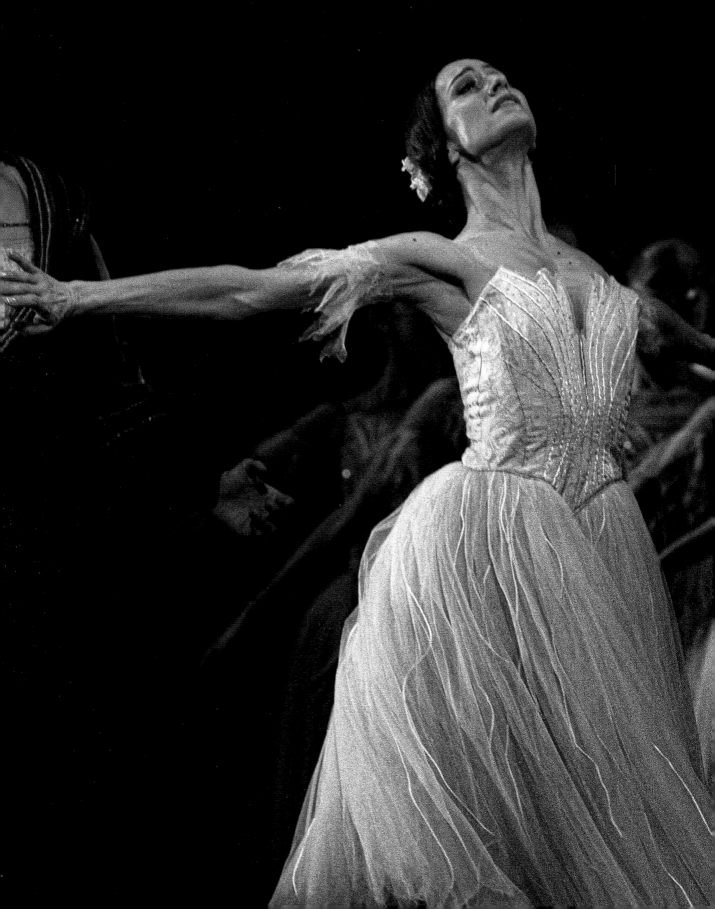

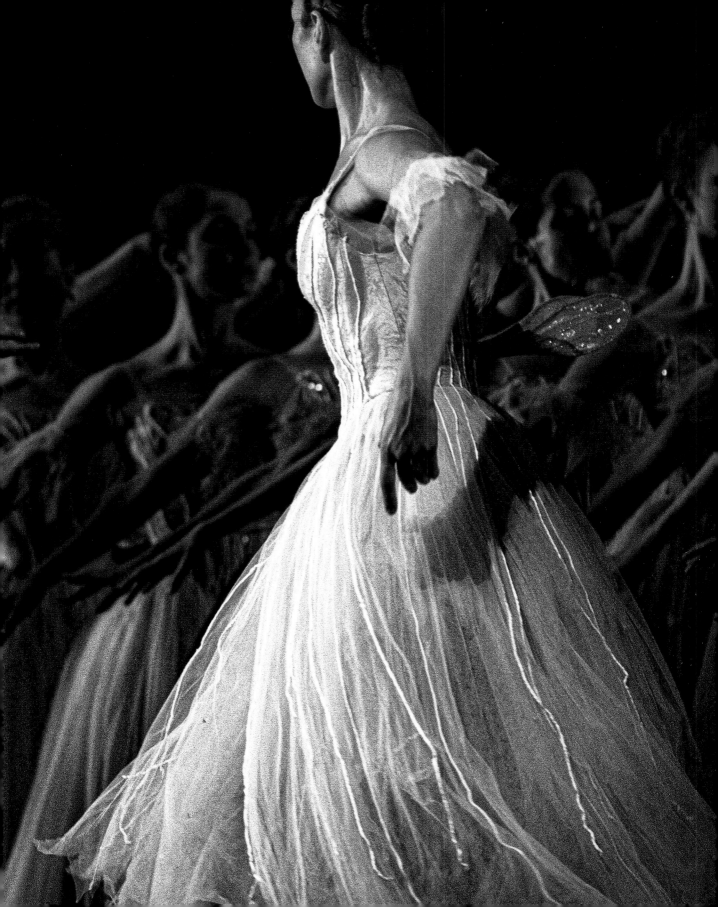

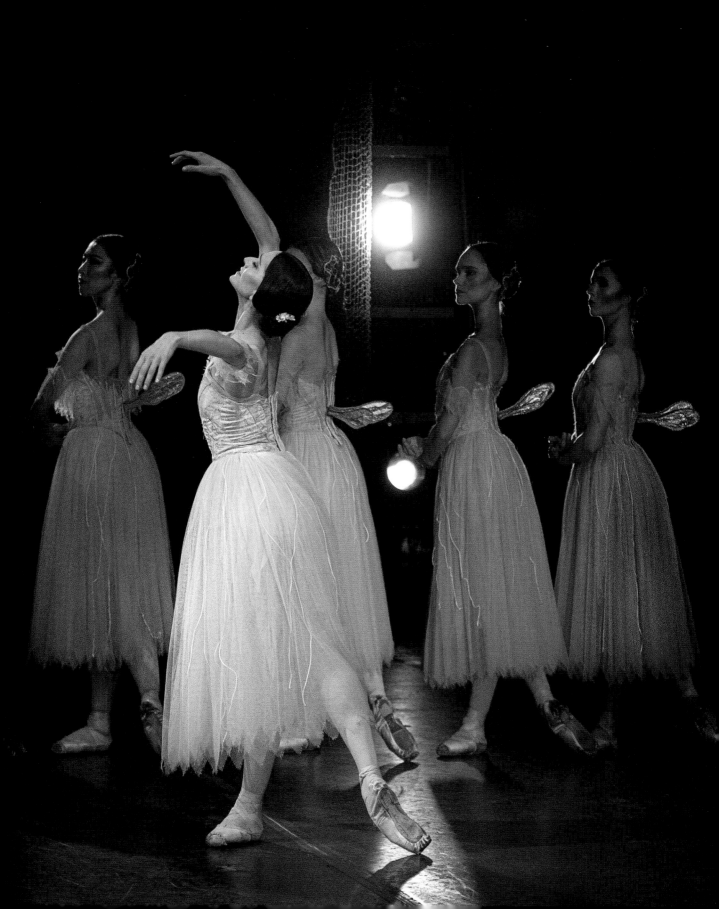

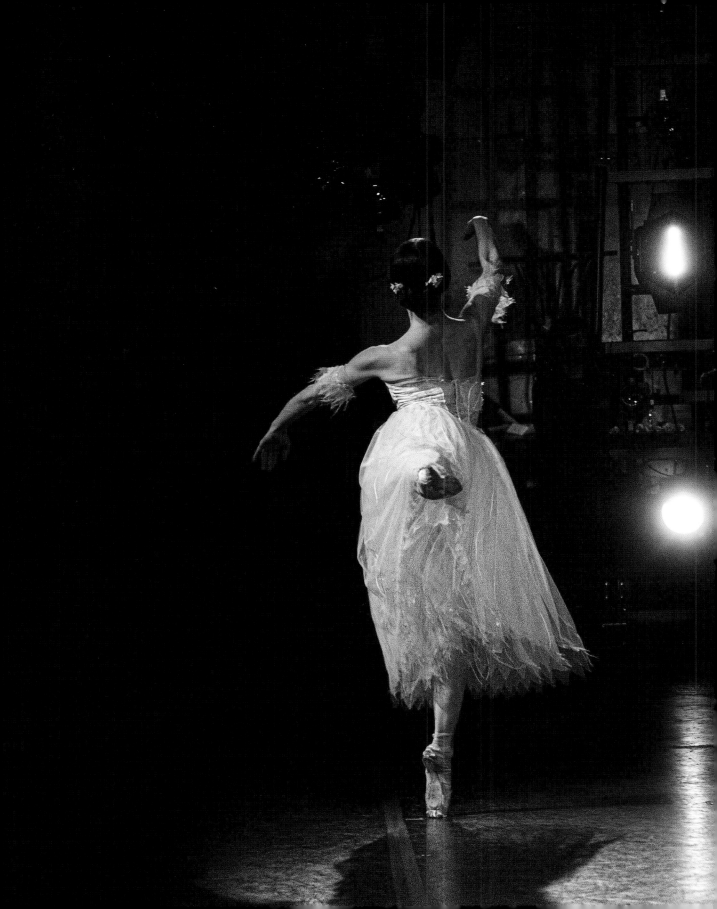

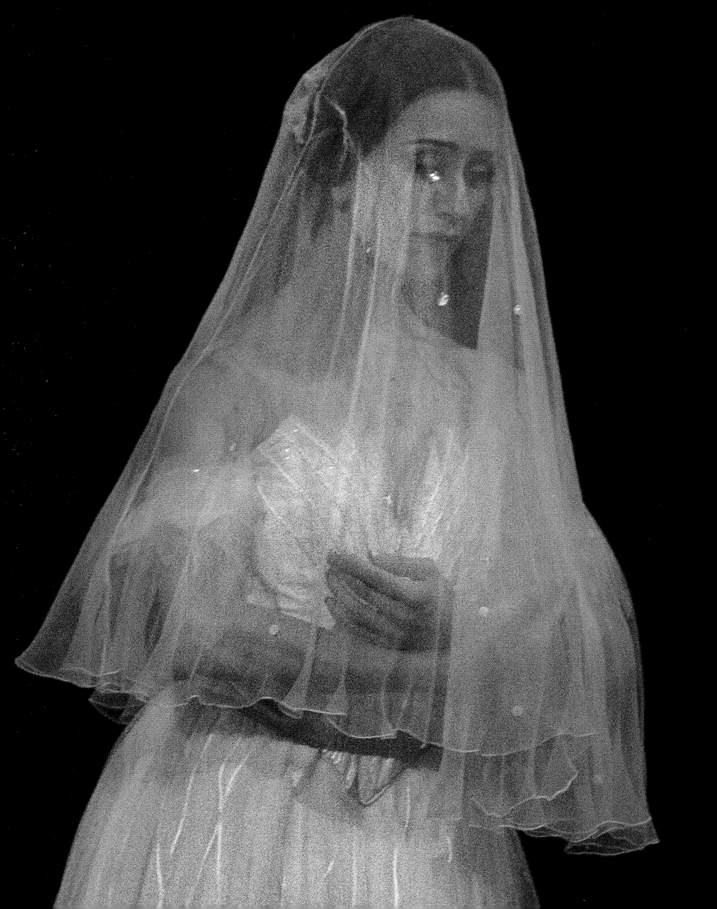

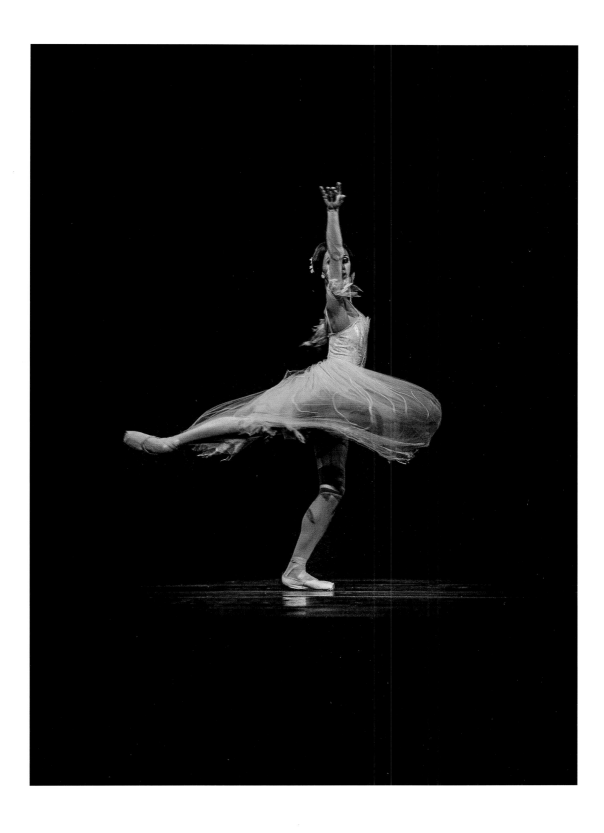

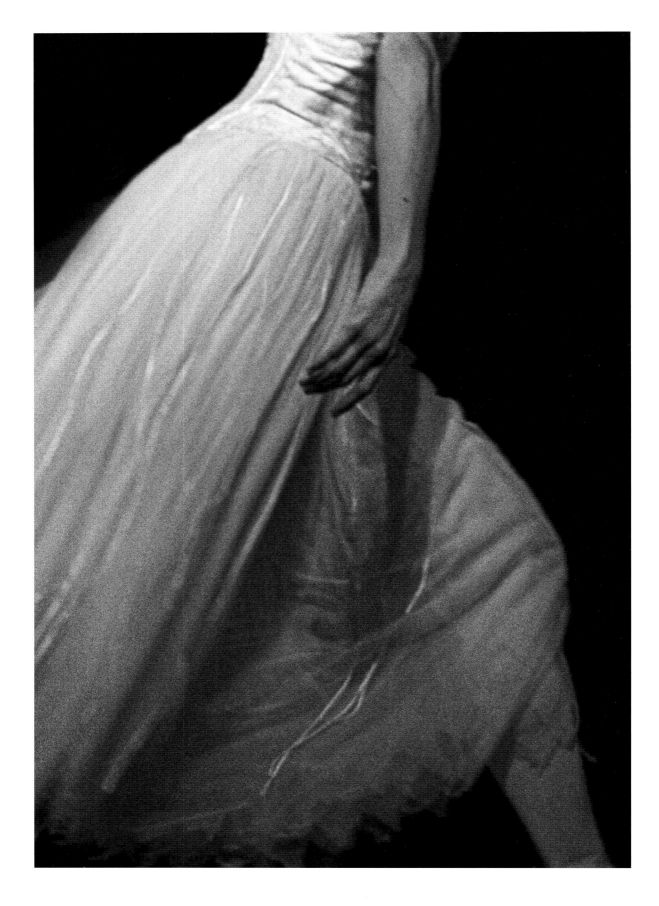

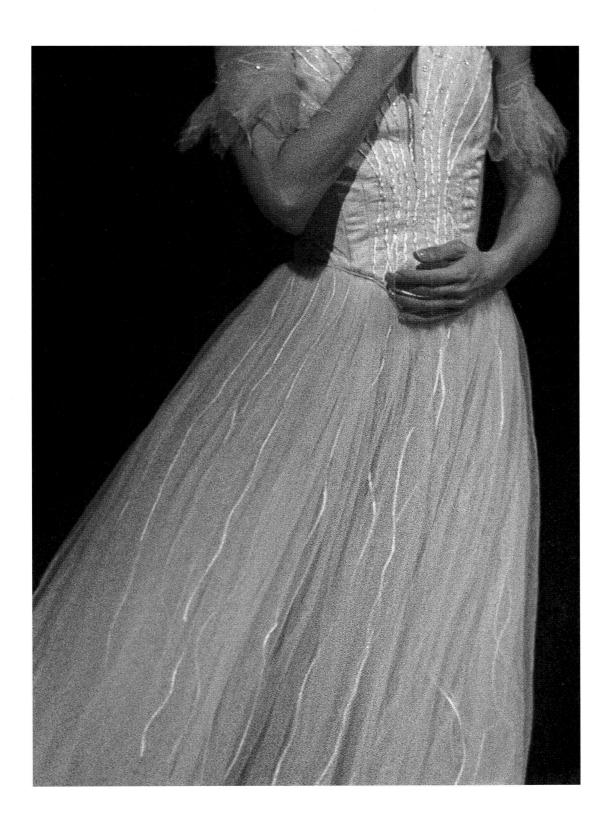

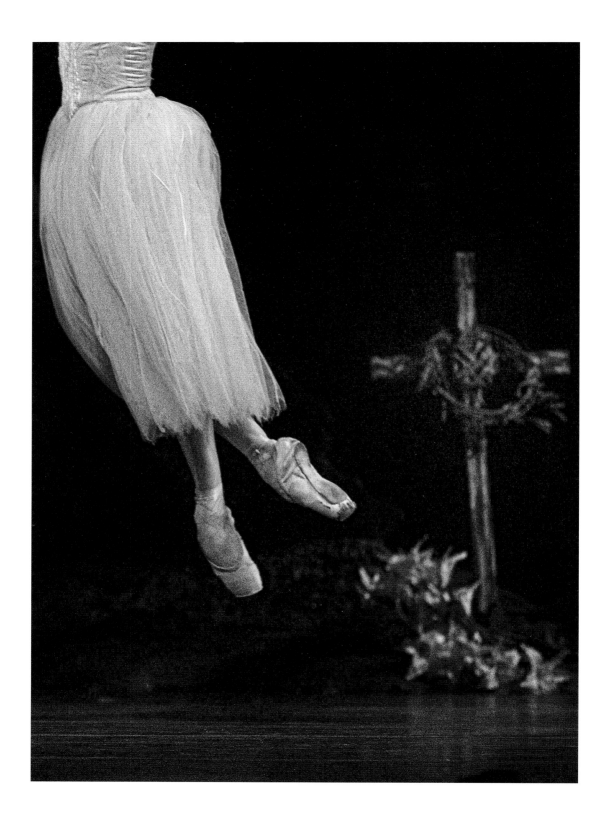

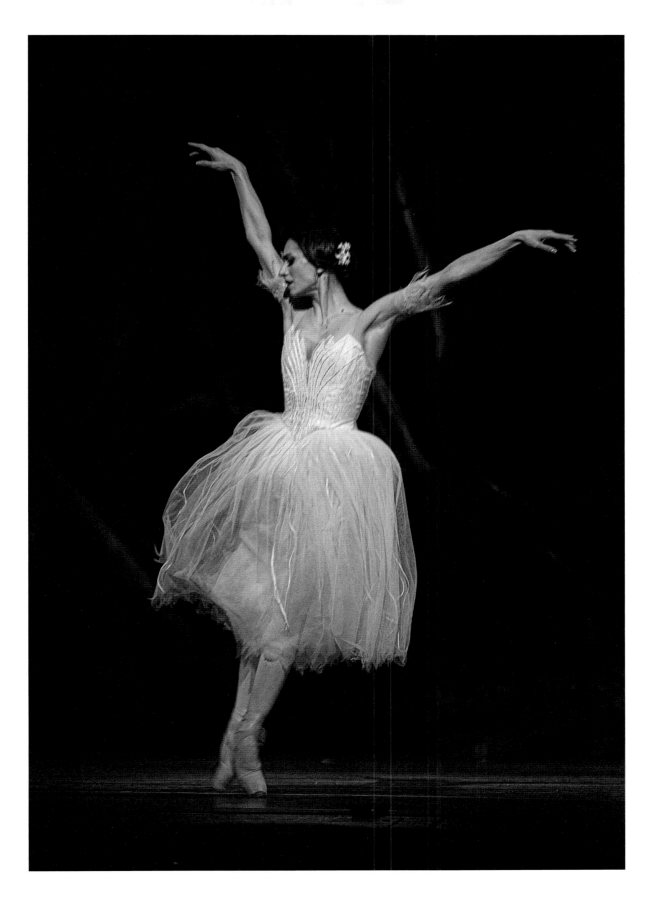

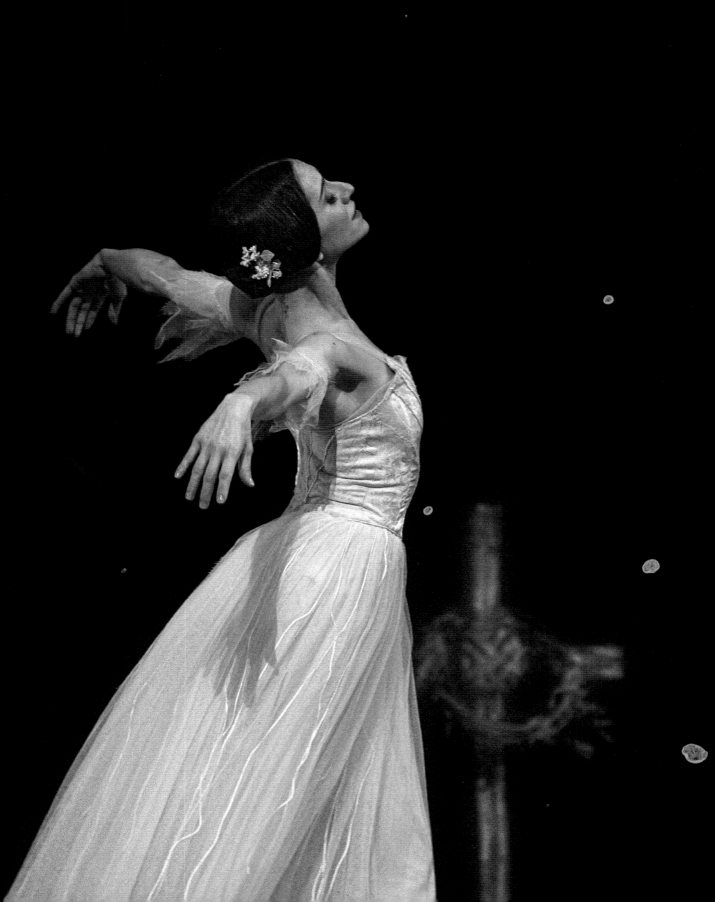

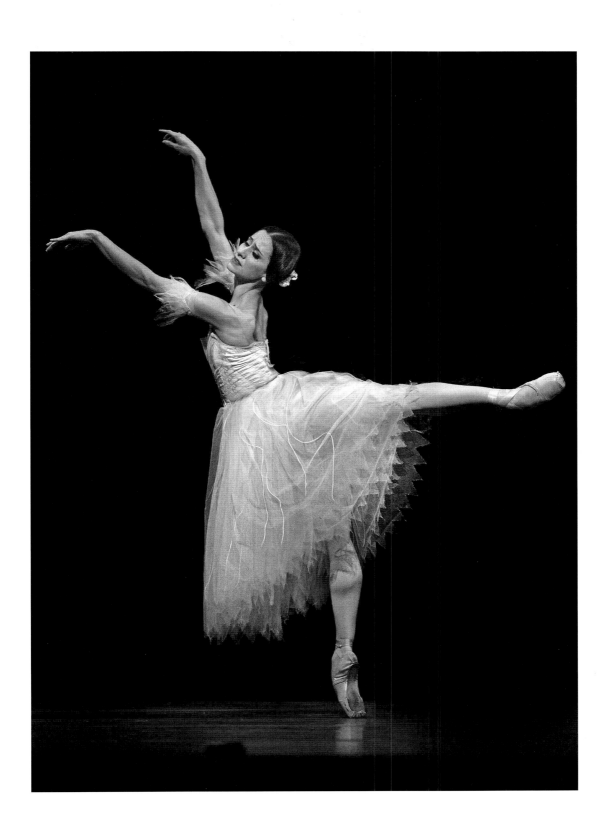

I believe fervently in the importance of seeing ballet: really watching, really taking in a performance, really thinking about what the choreographers and artists are saying. It's not all about technique and physicality. We have to learn from the art form for it to thrive.

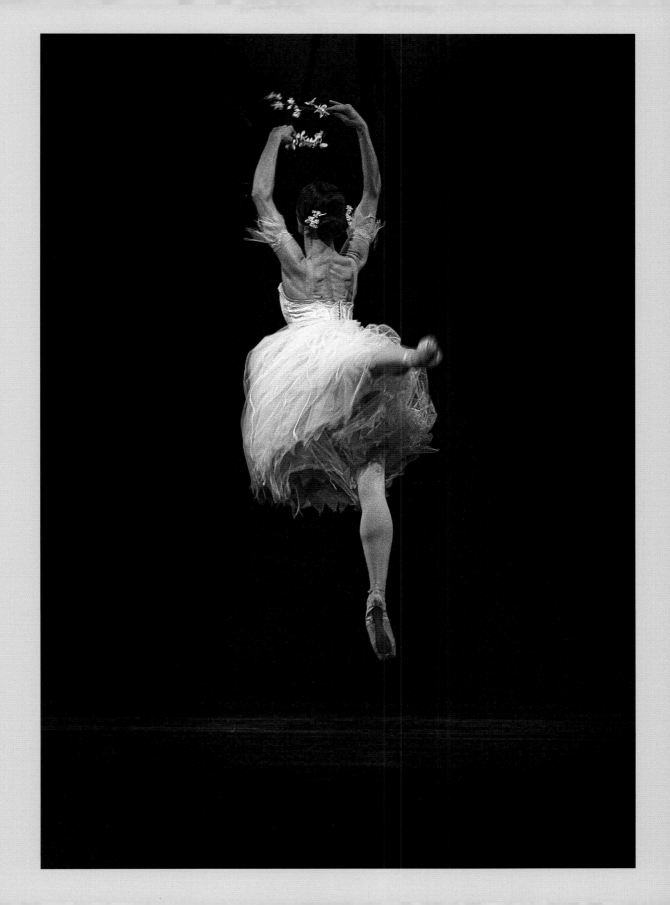

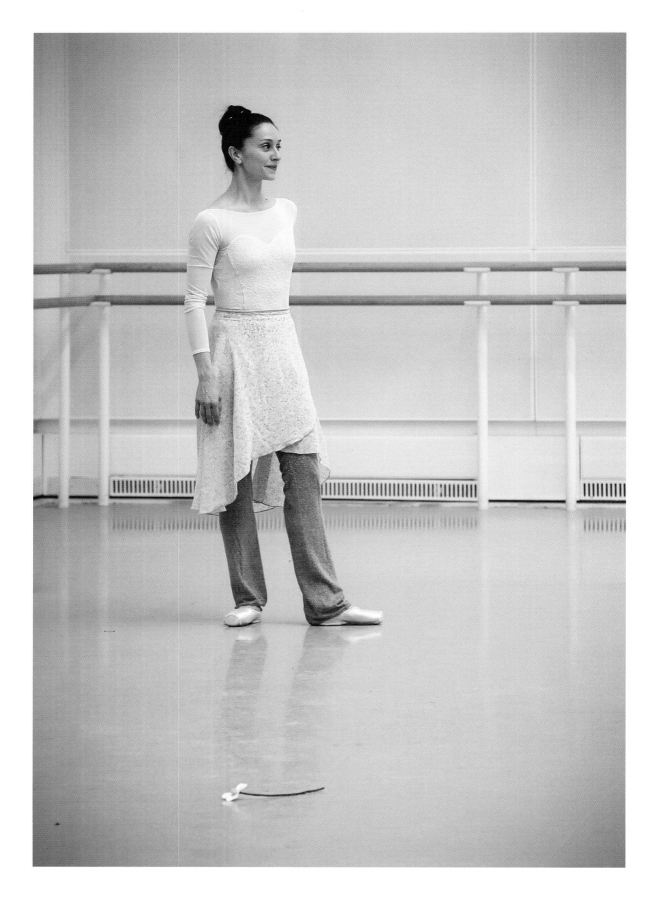

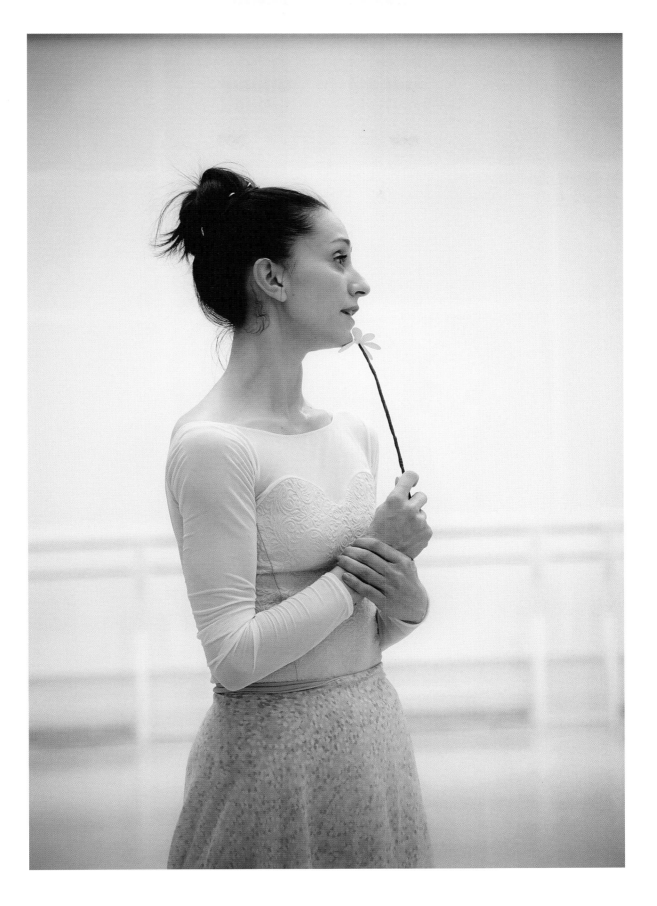

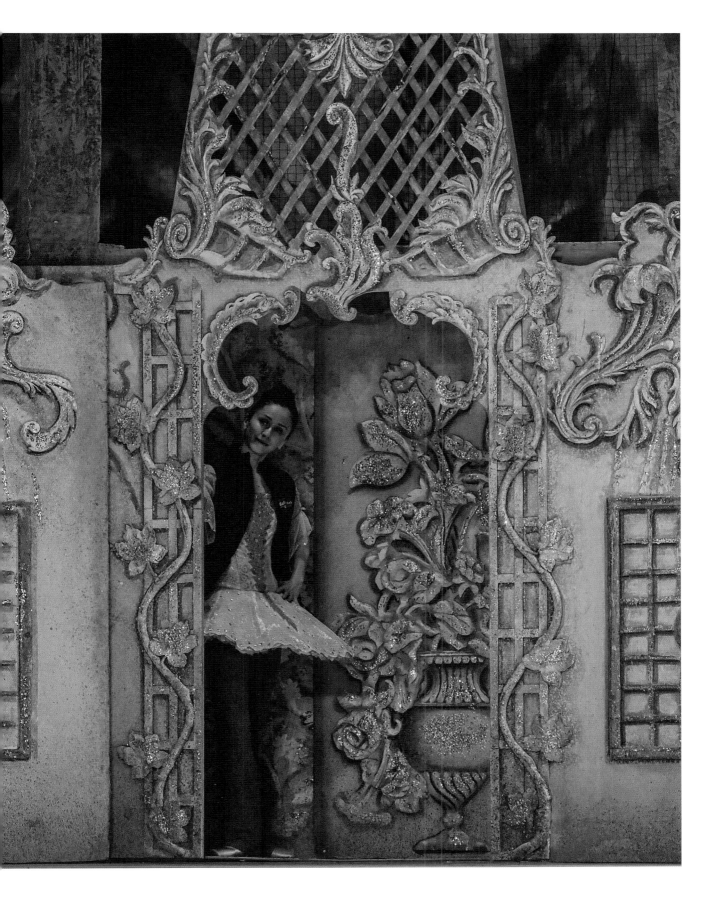

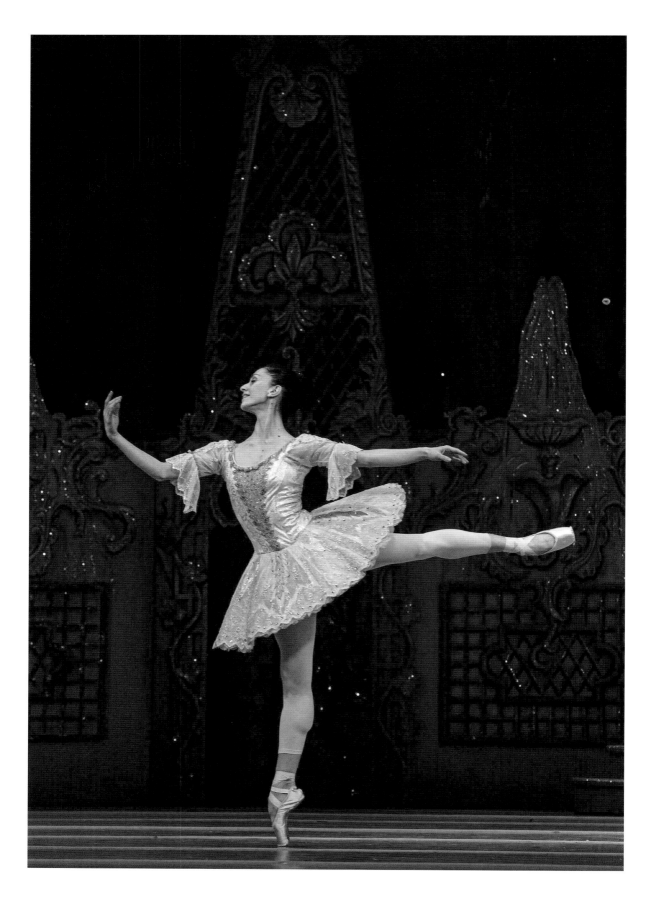

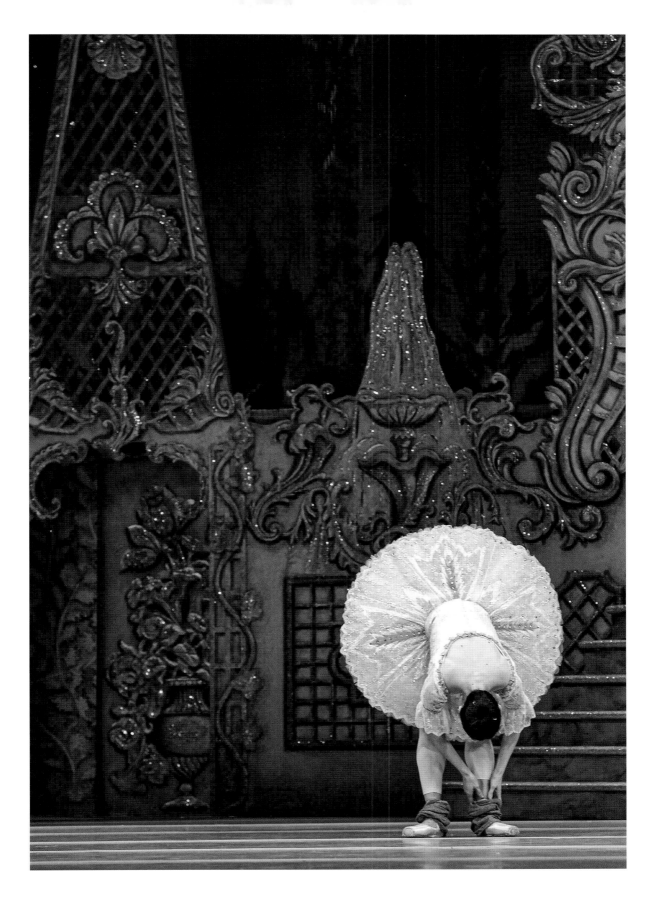

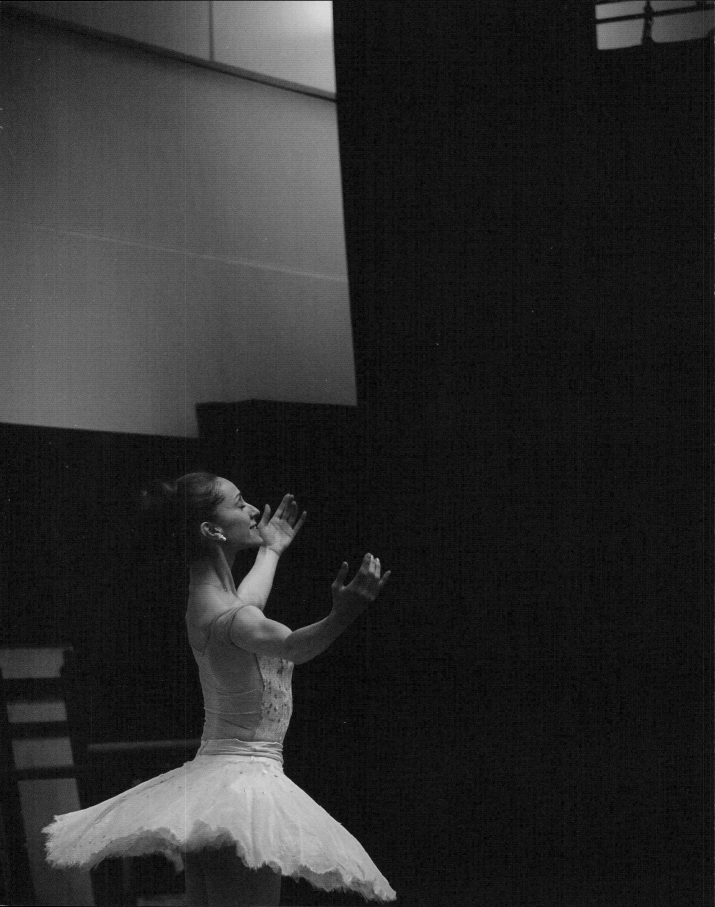

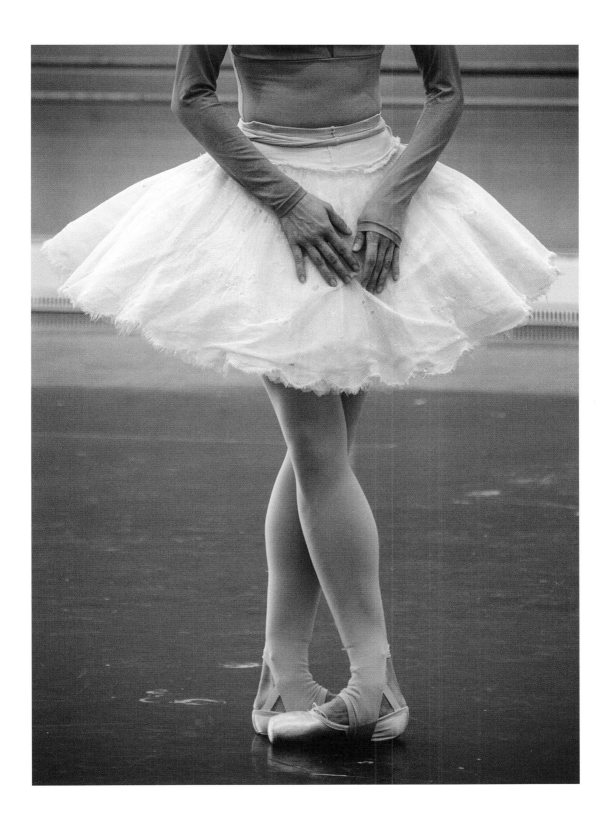

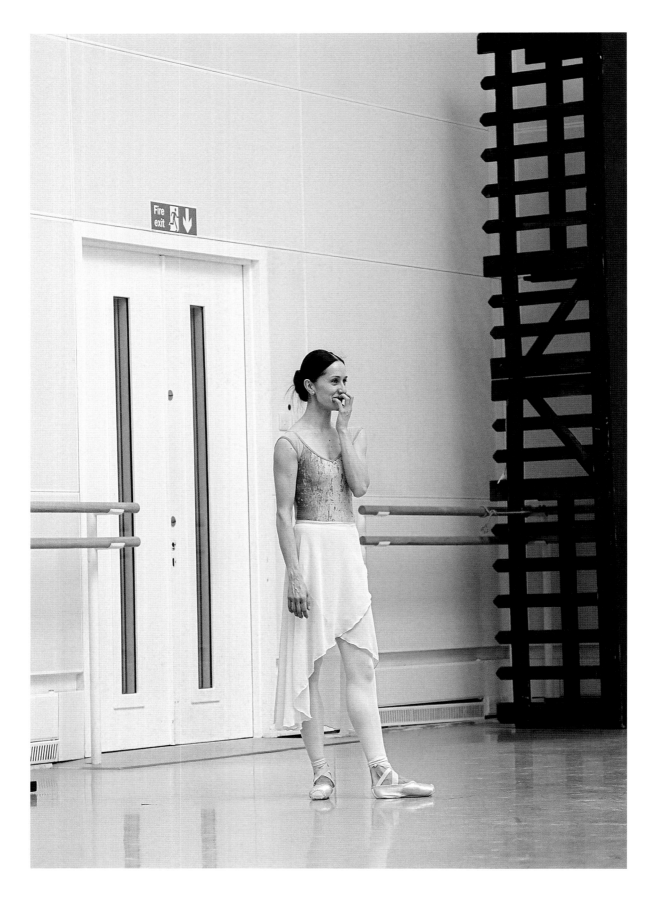

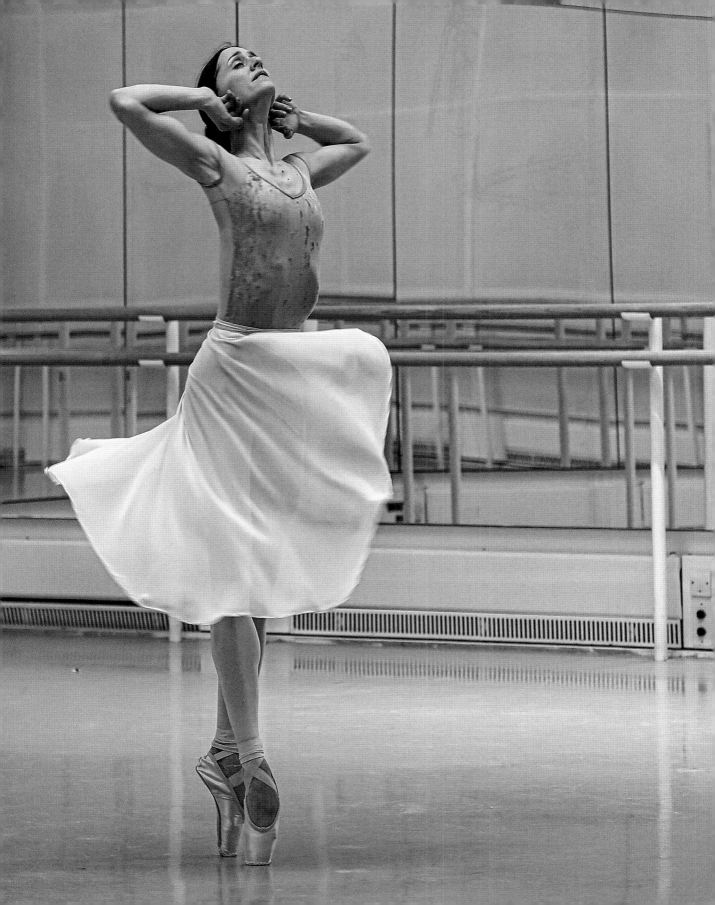

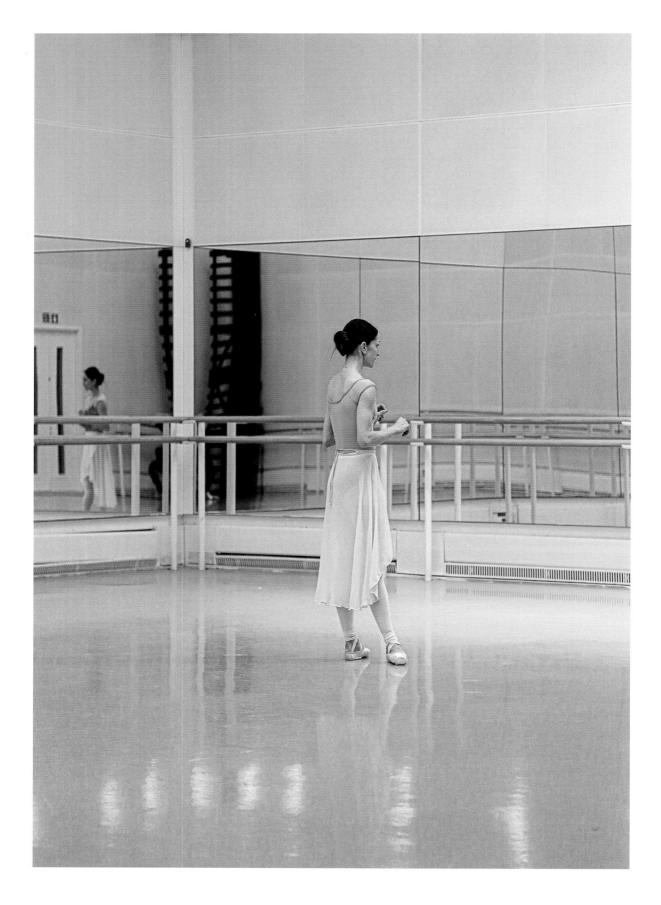

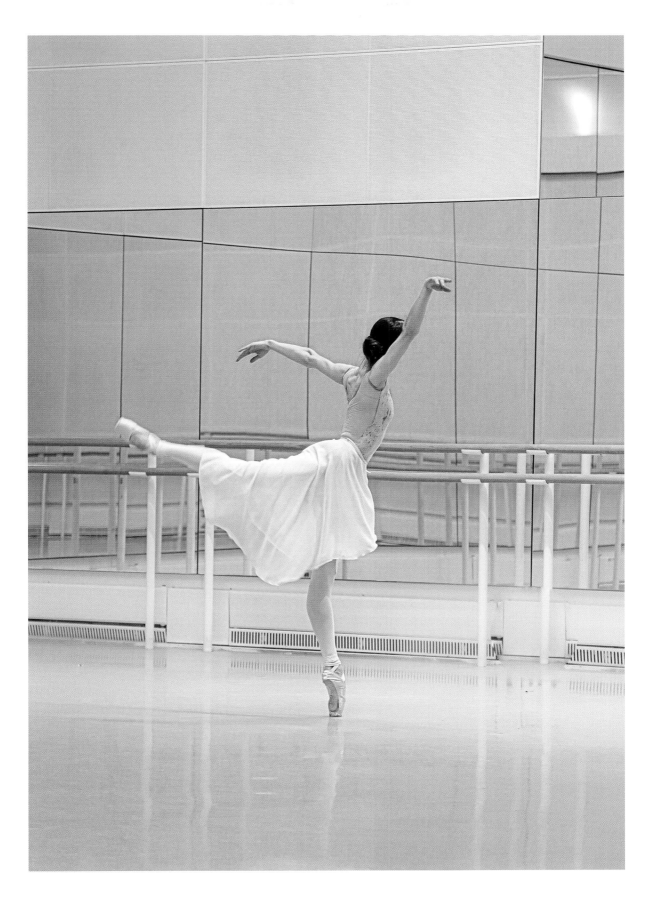

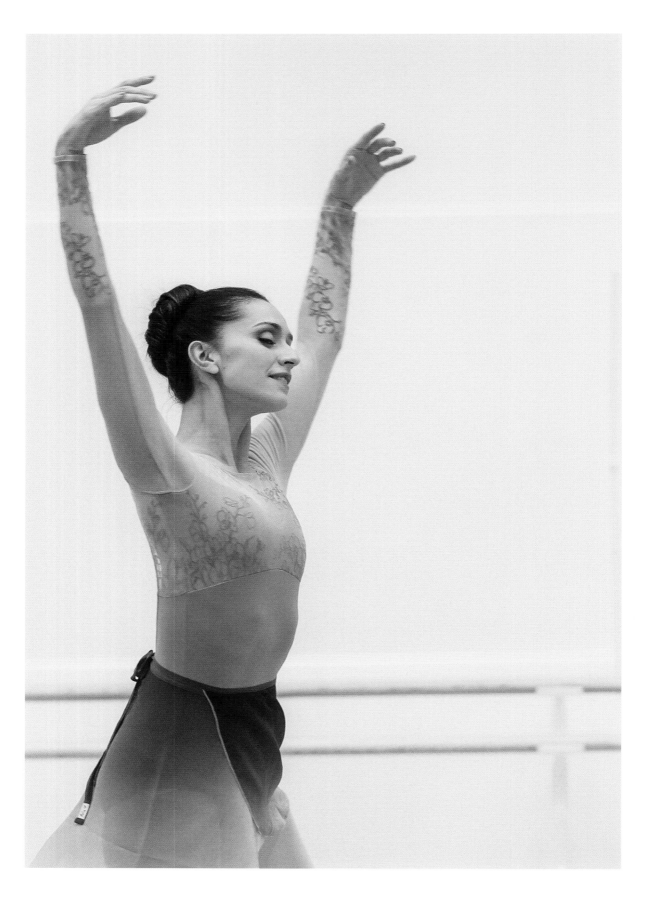

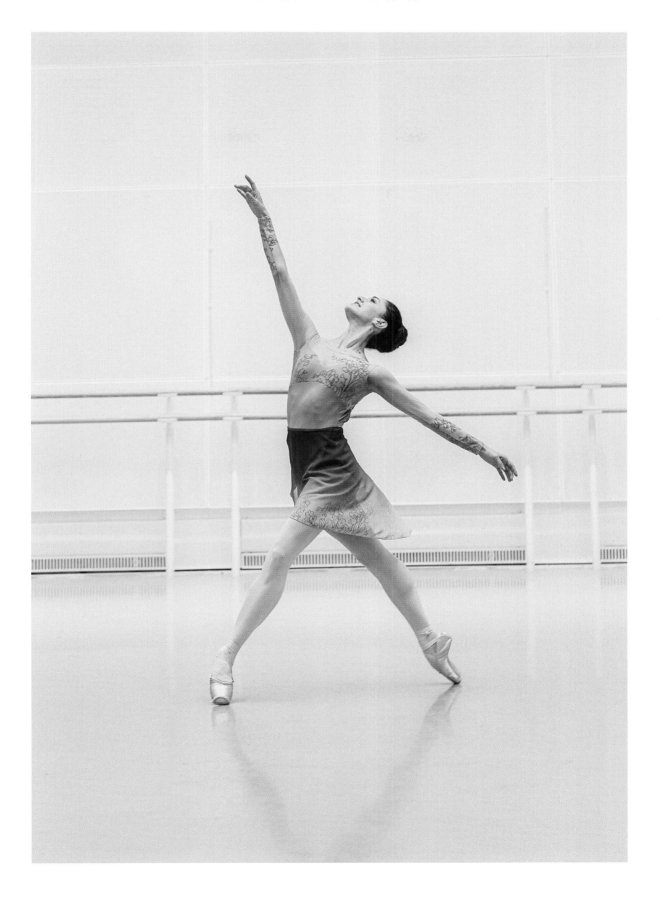

I feel totally confident about the future of ballet. The younger generation is passionate about the art form.

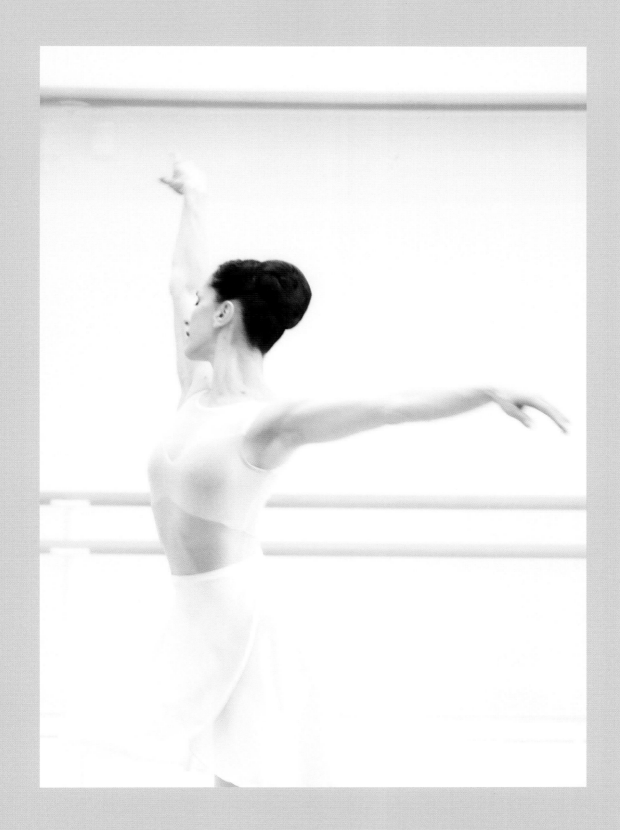

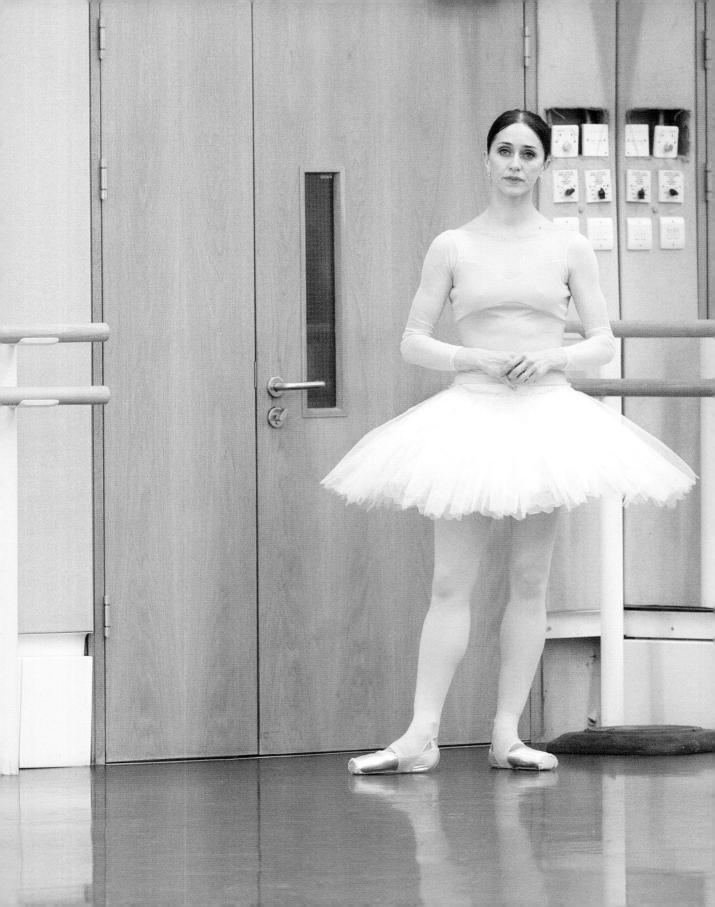

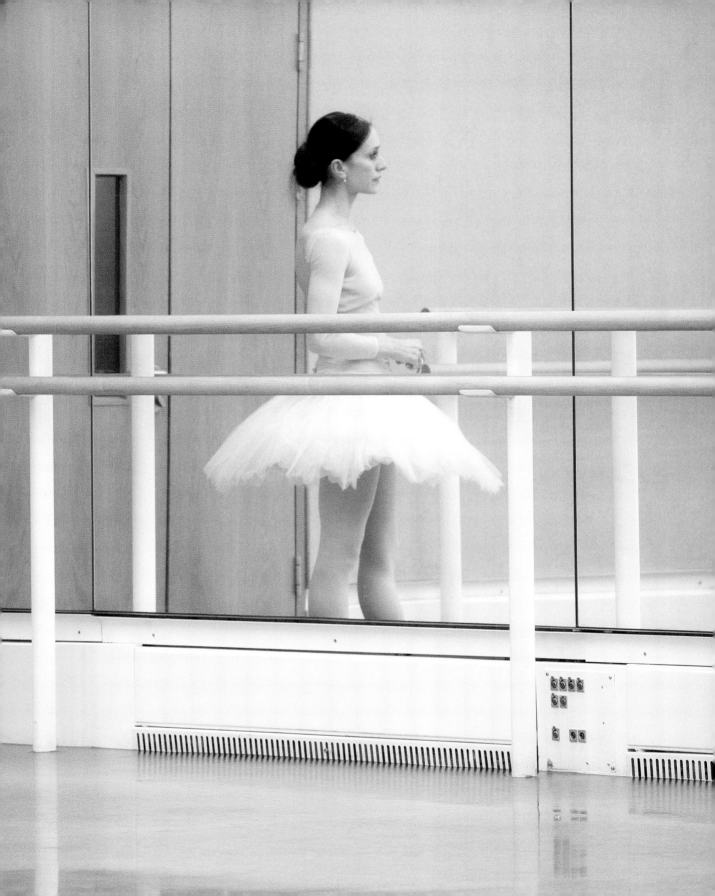

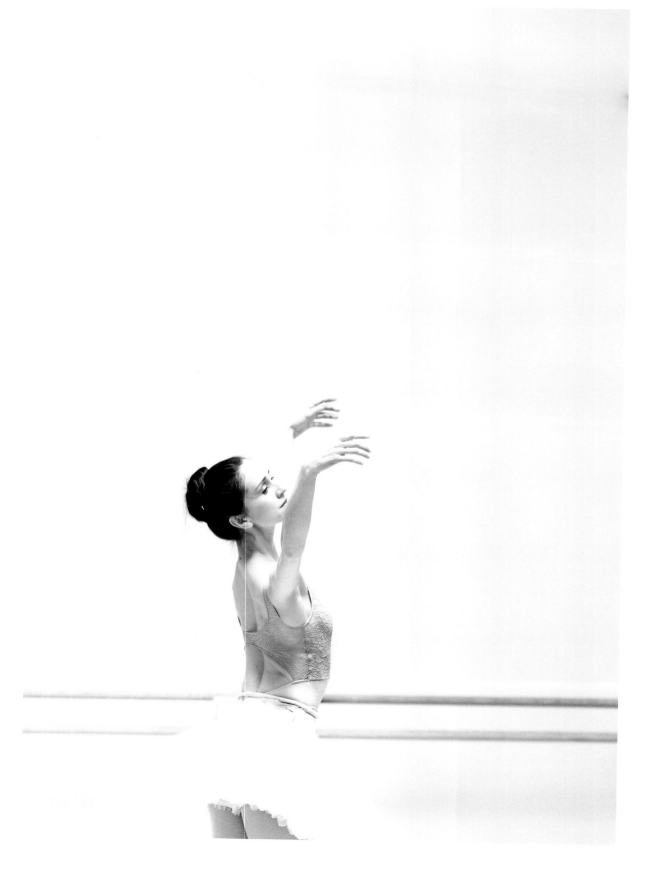

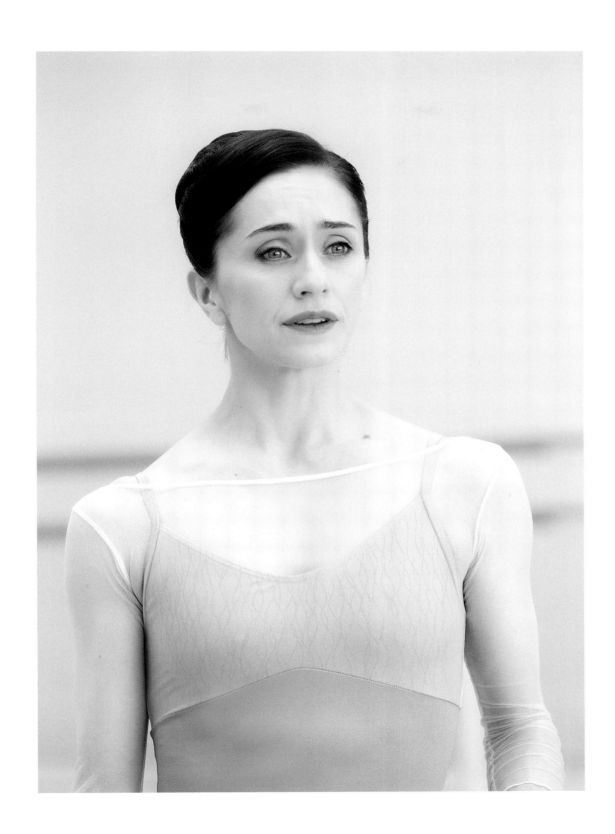

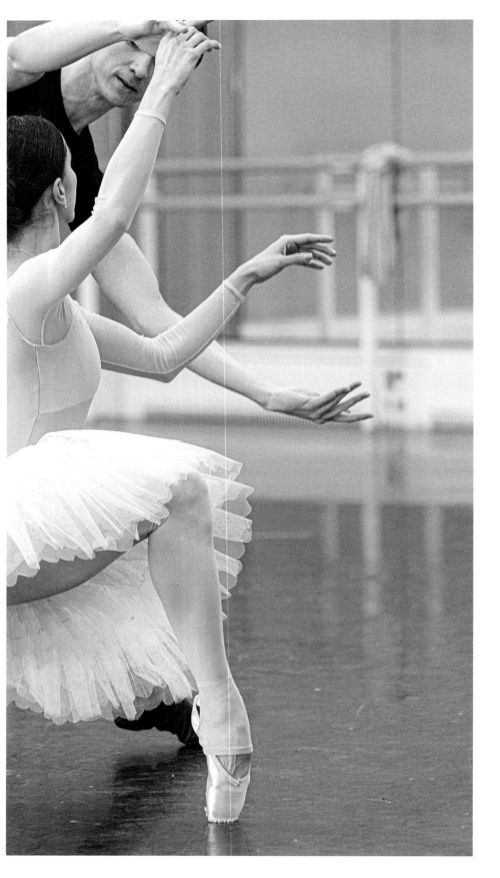

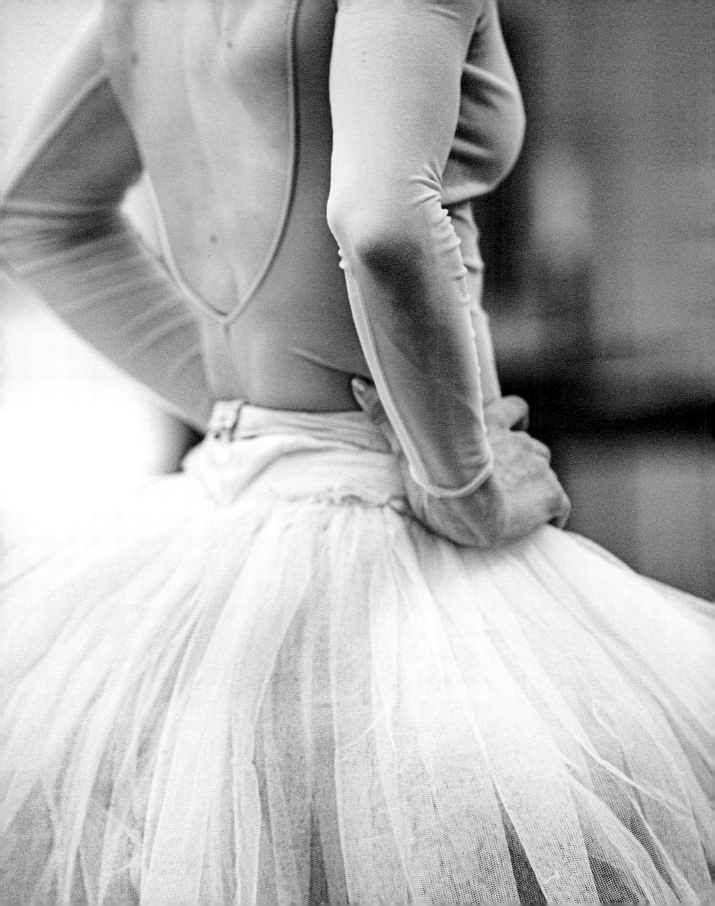

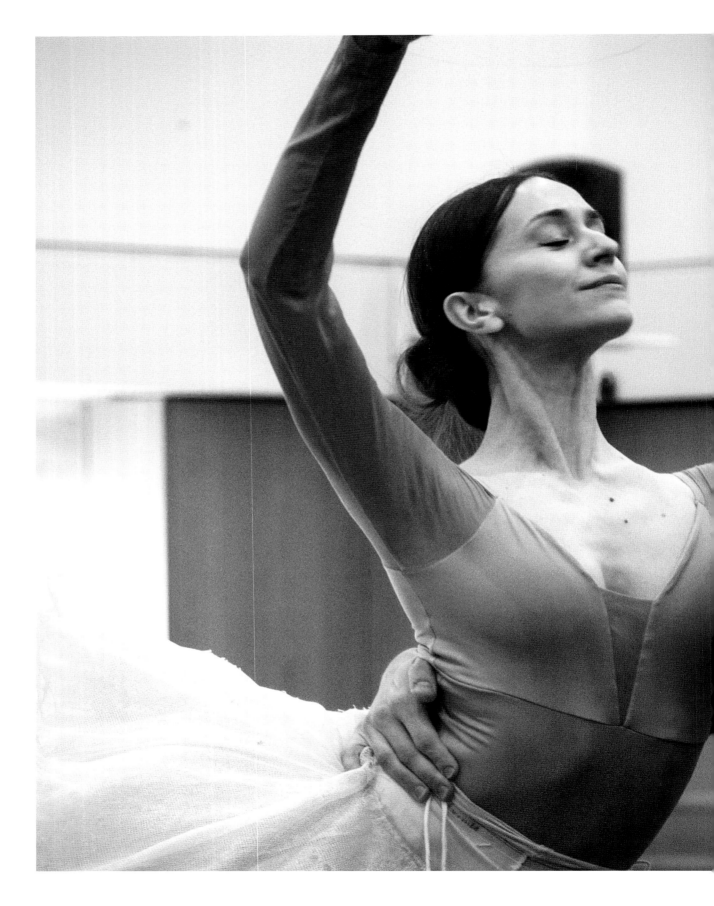

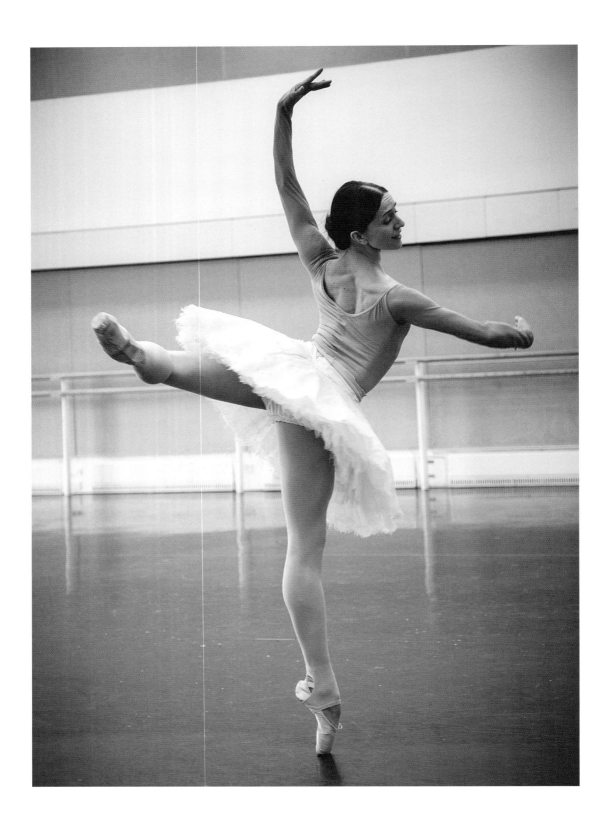

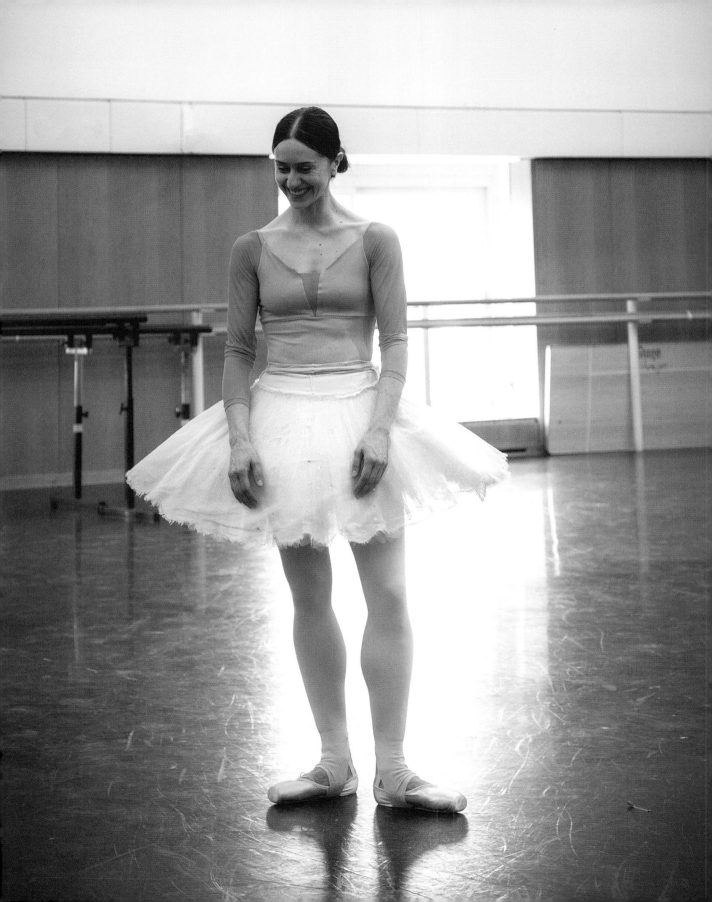

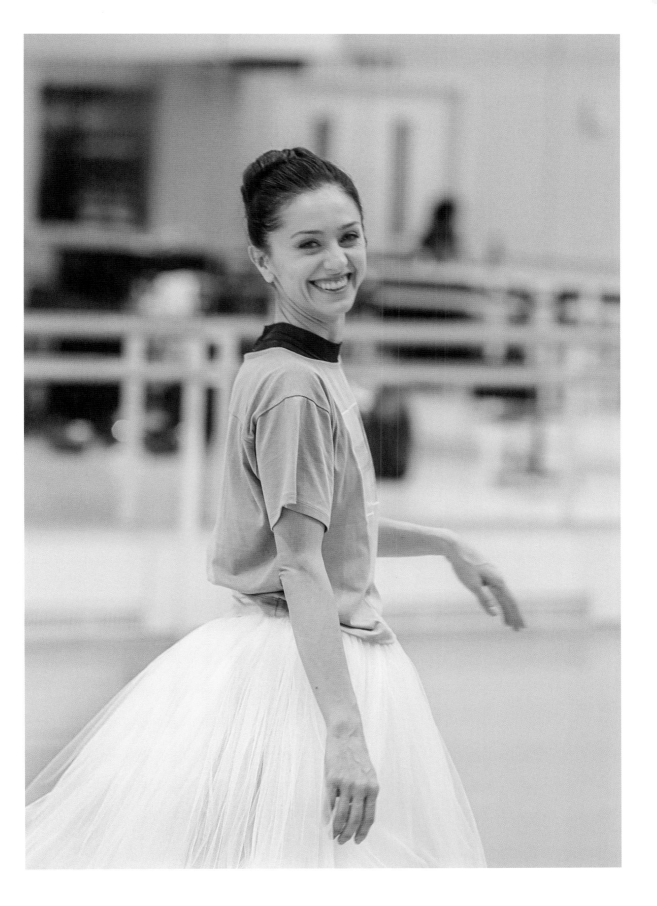

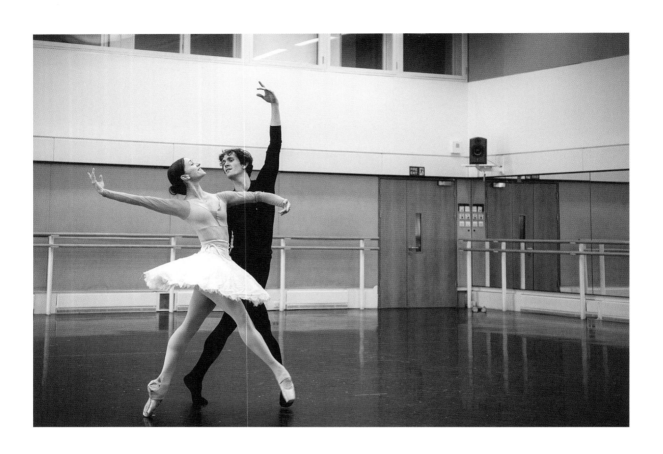

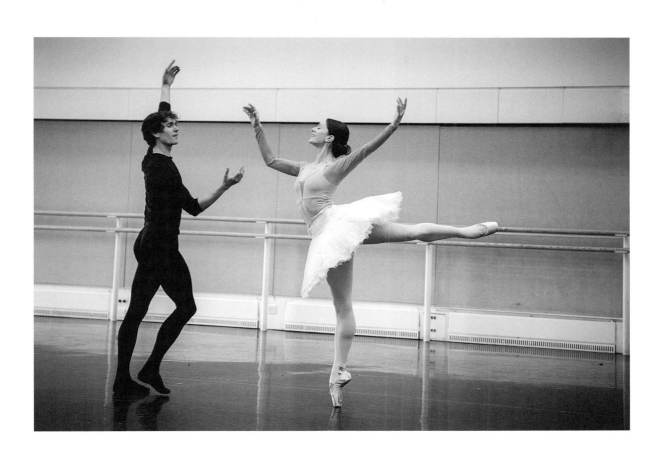

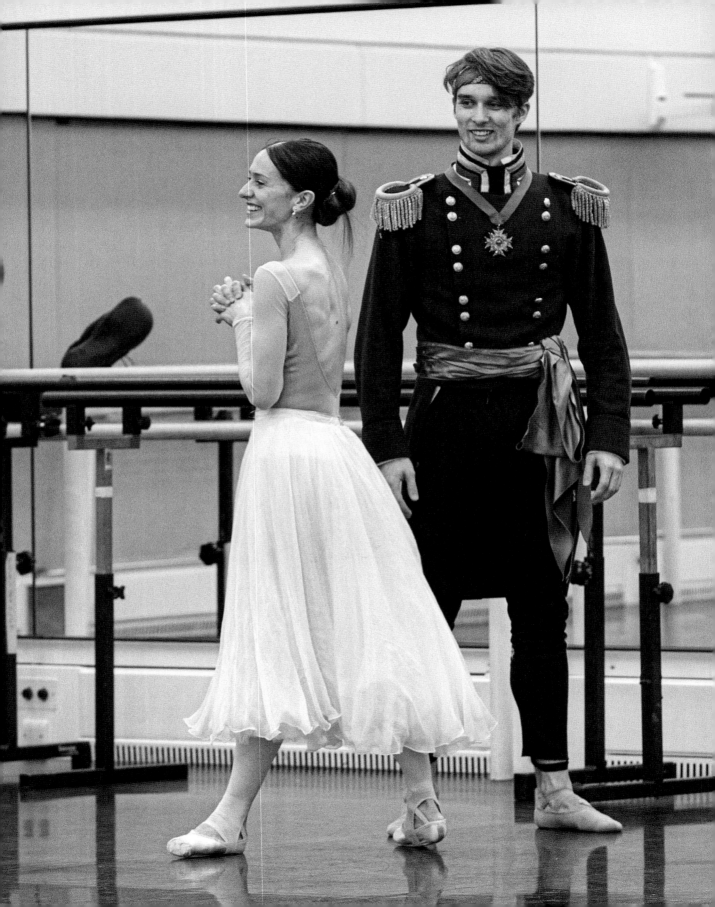

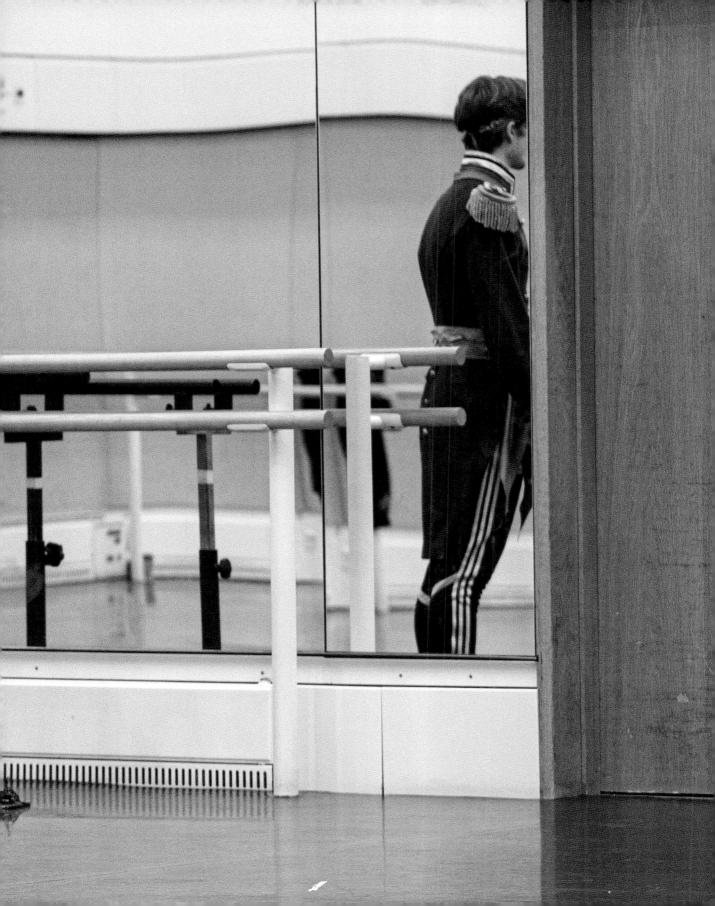

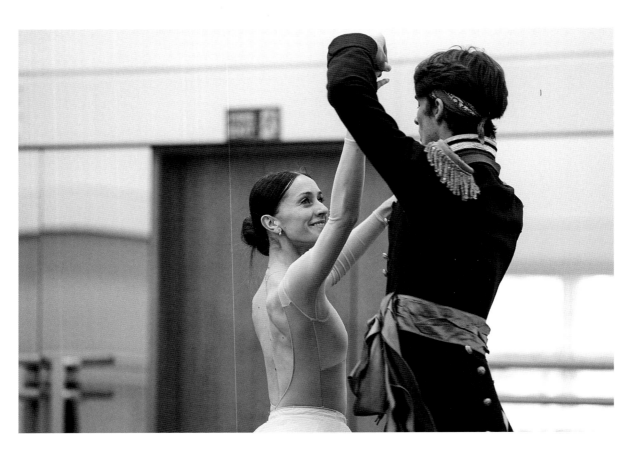

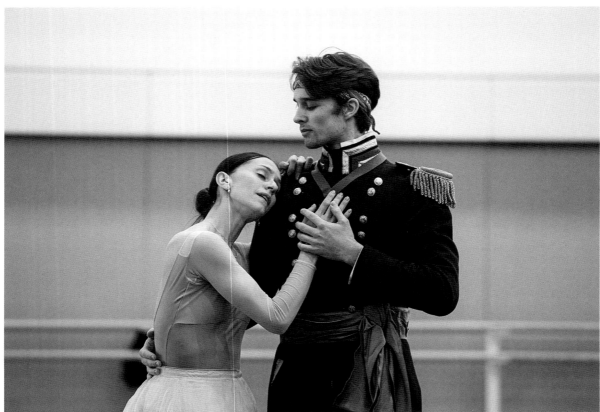

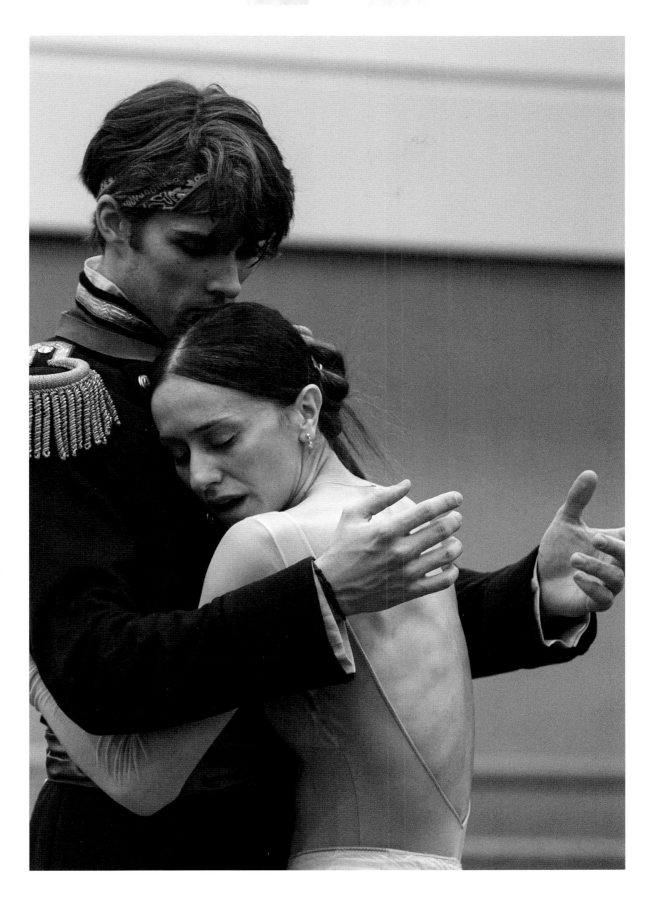

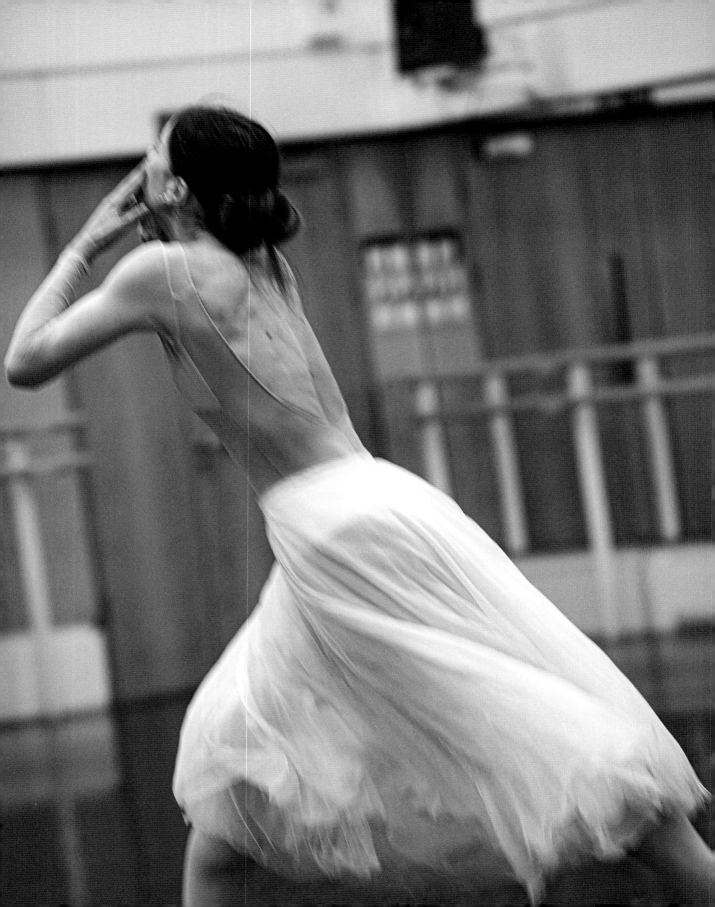

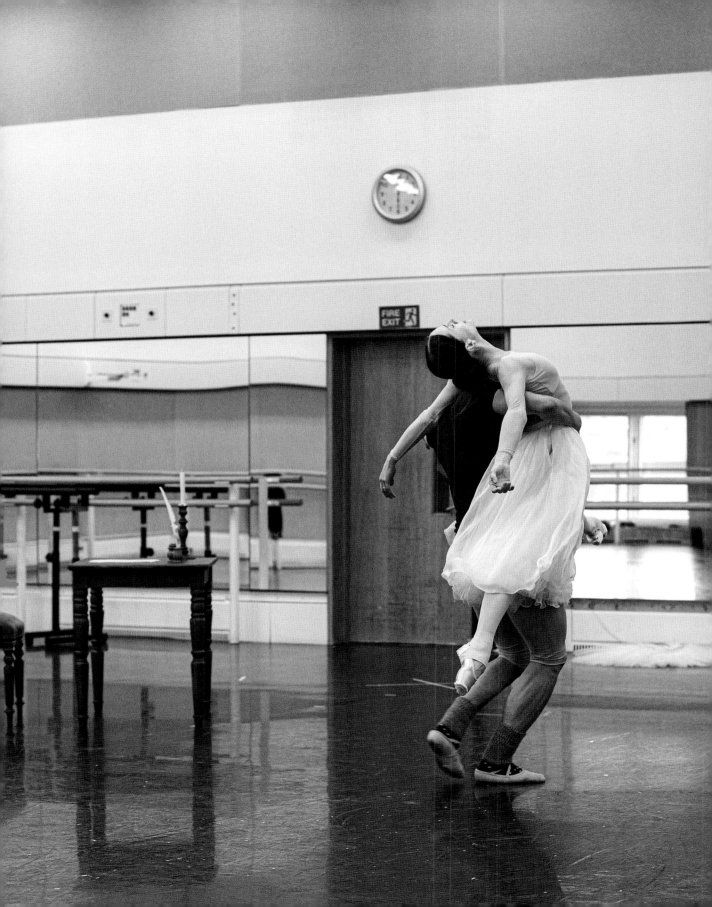

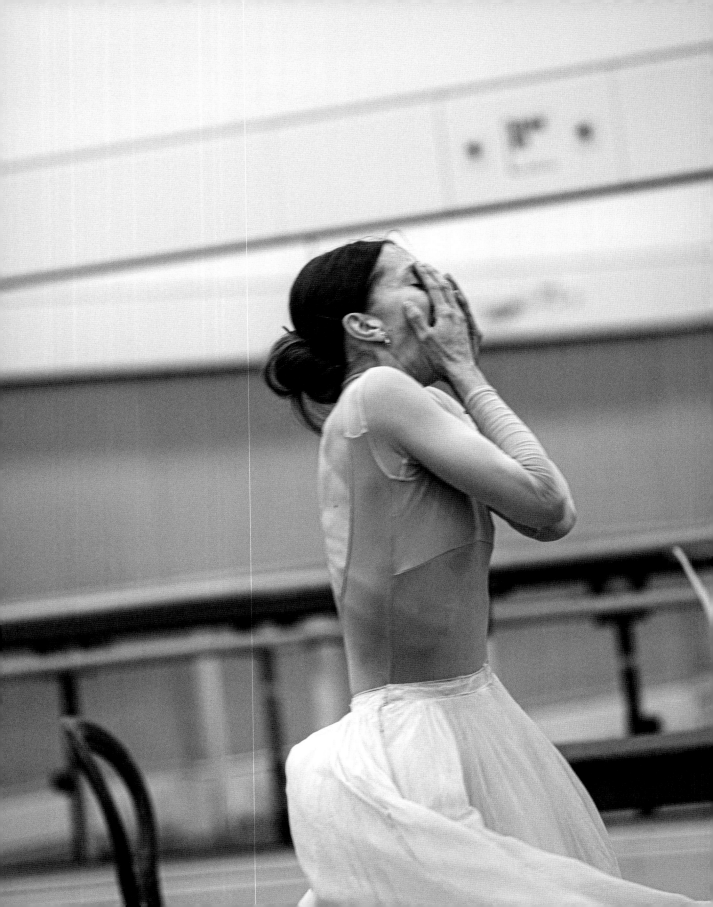

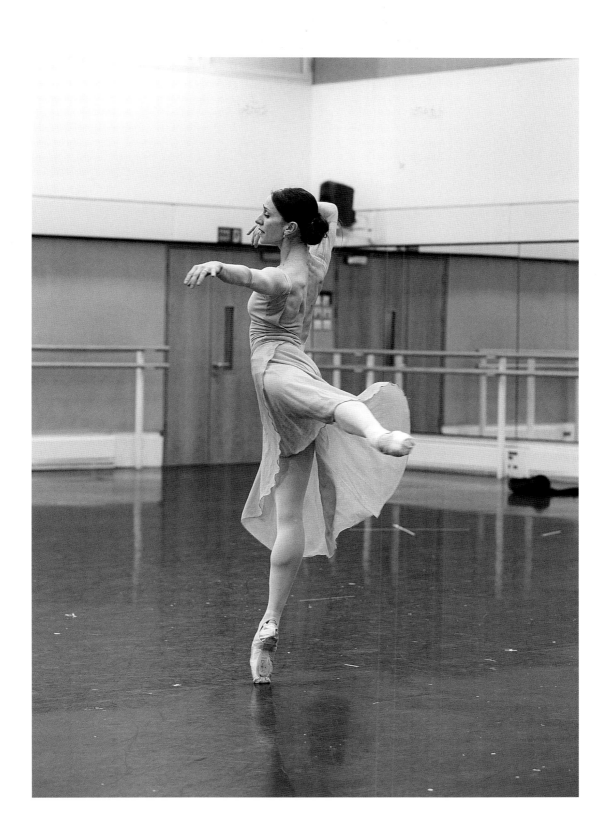

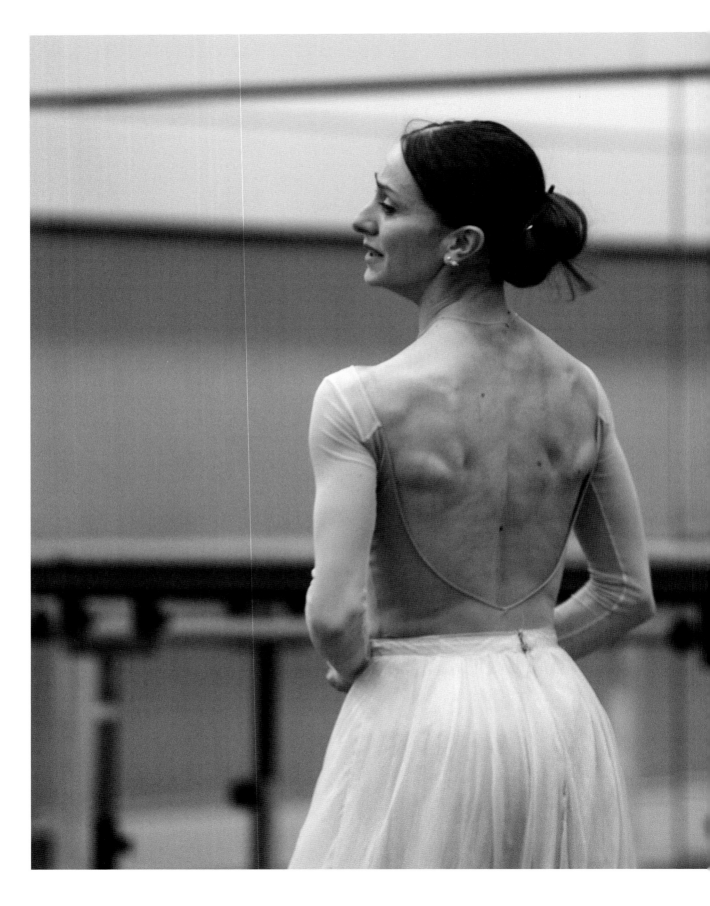

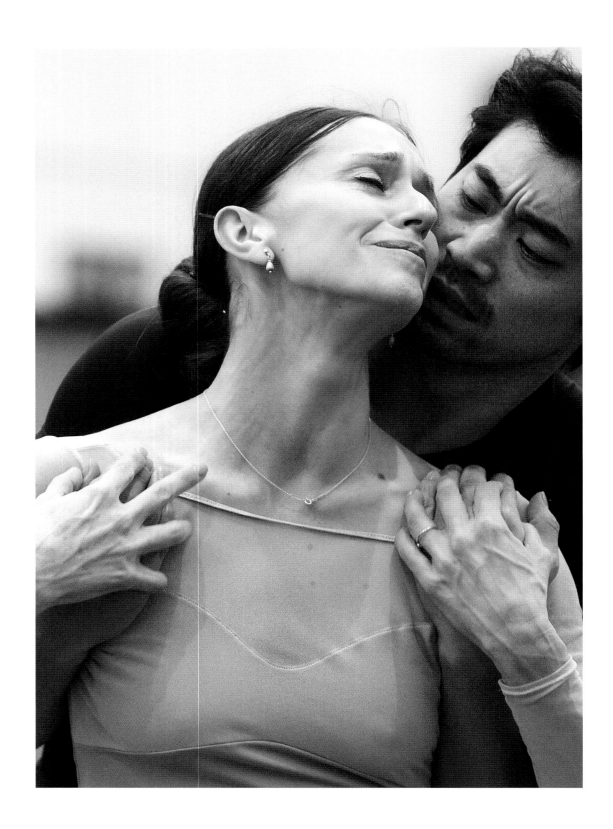

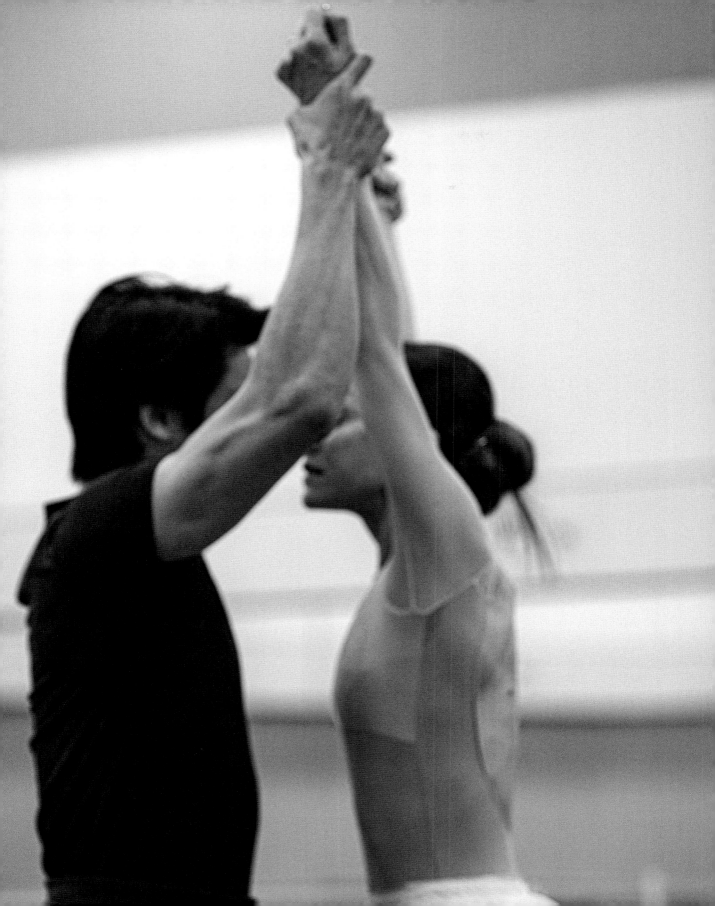

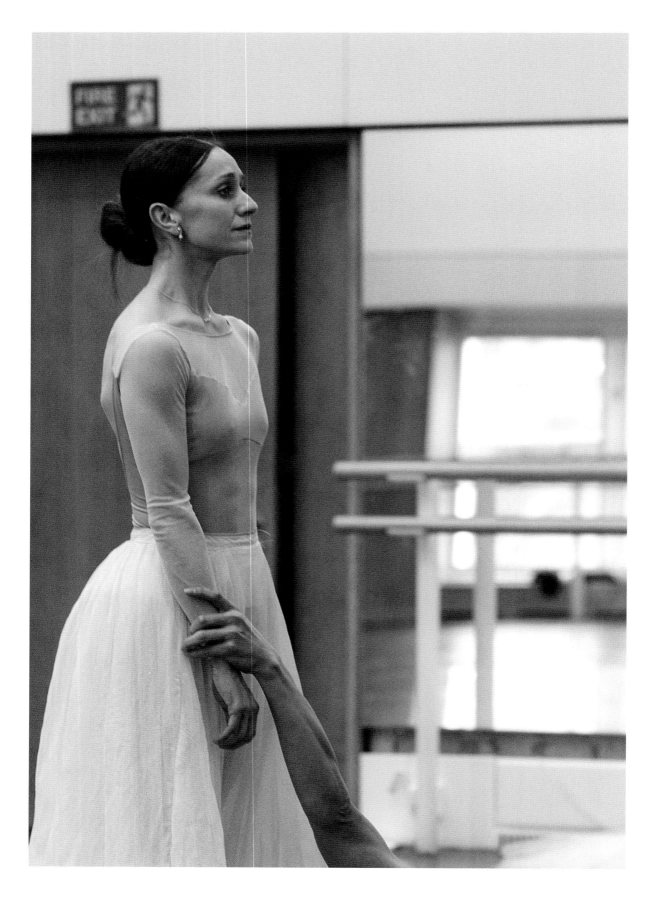

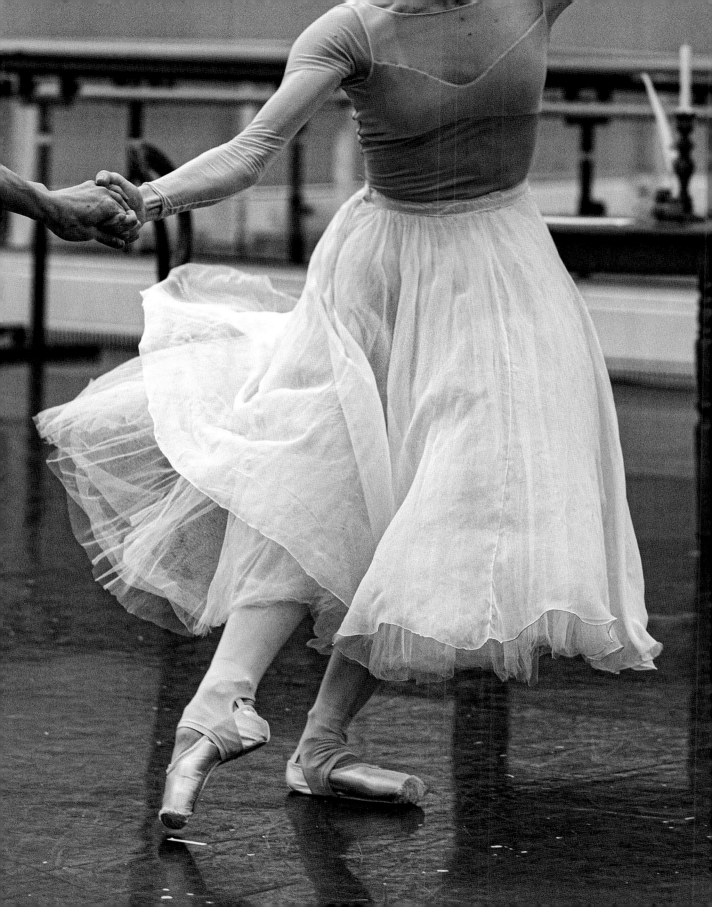

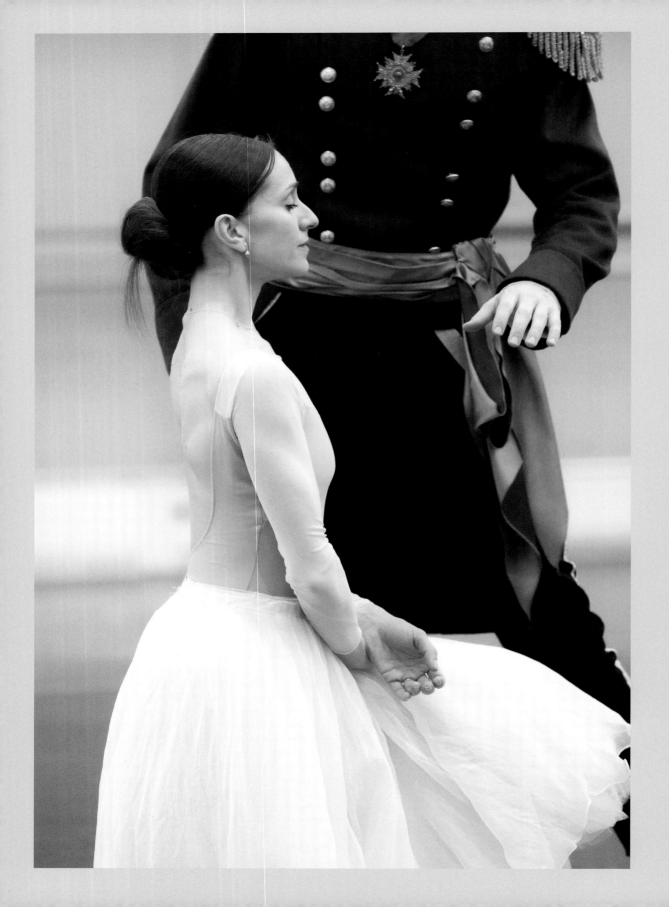

Onegin *is one of those ballets that makes you grow as an artist. There is such a clear journey following Tatiana's arc from youth to maturity. As my life has changed, so my understanding of her has deepened. She is a good woman, meeting the emotional challenges of her experience with strength and dignity. There can't be one woman who doesn't relate to her.*

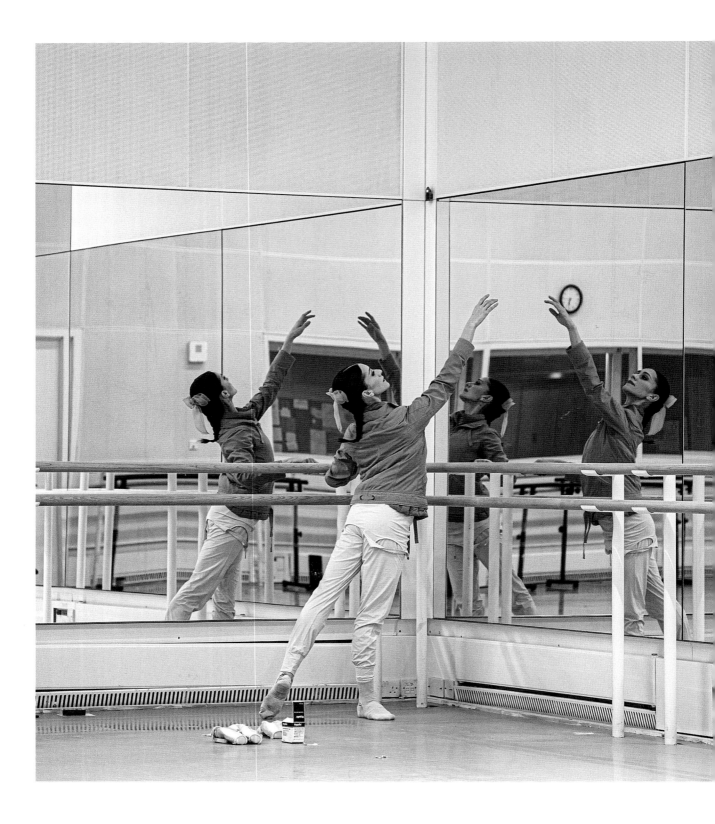

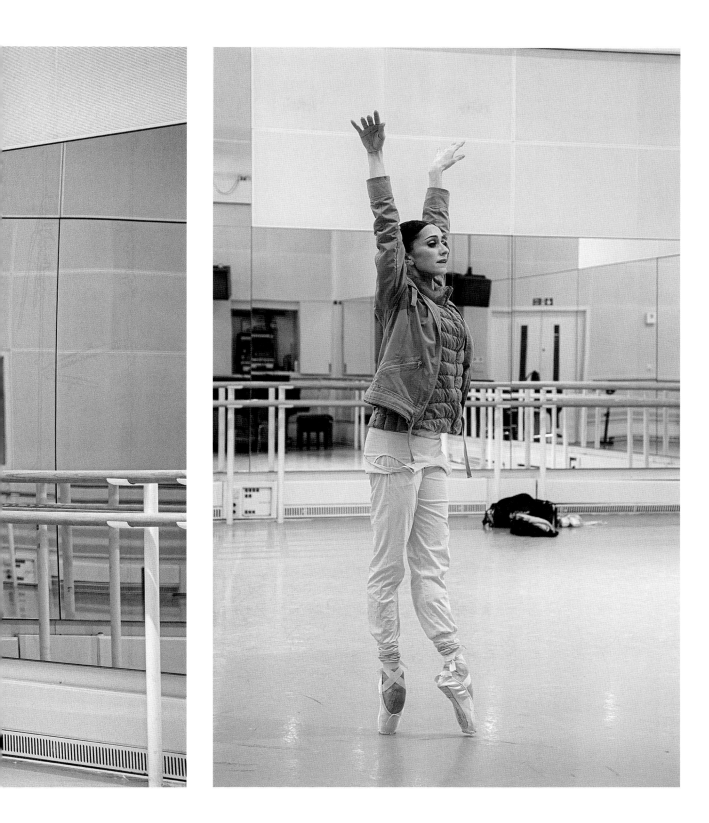

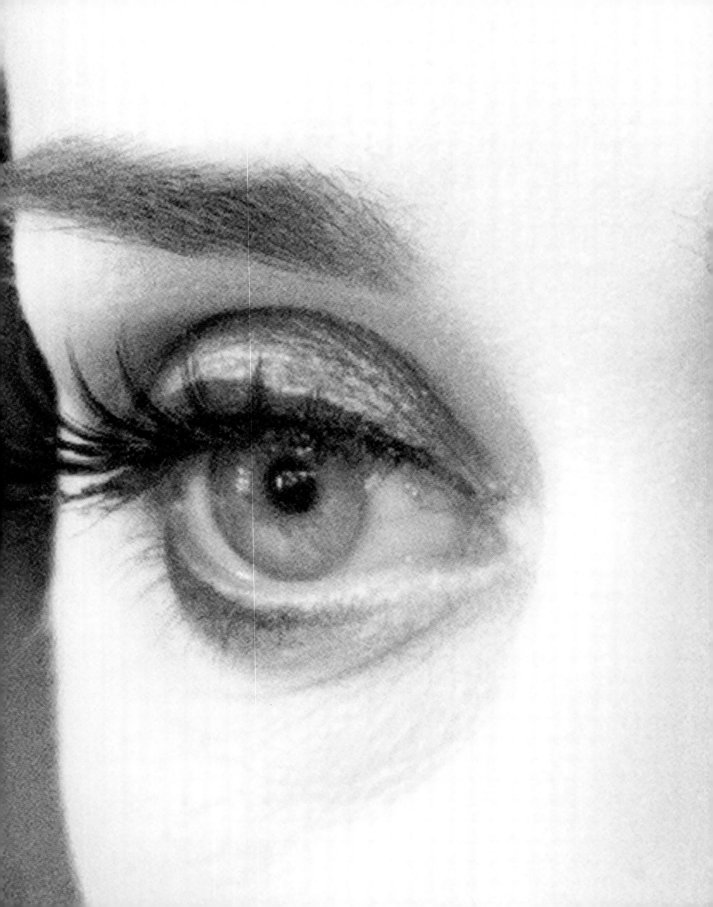

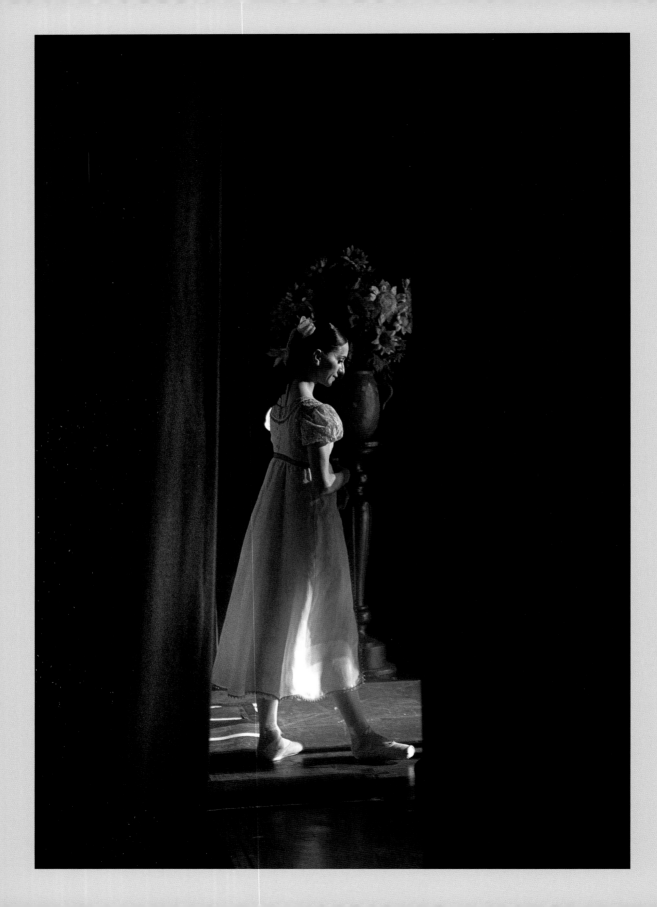

I love the sense of community in dance. It's not just that audiences appreciate my art; it's about them seeing the person, about a simplicity of connection. It feels very human.

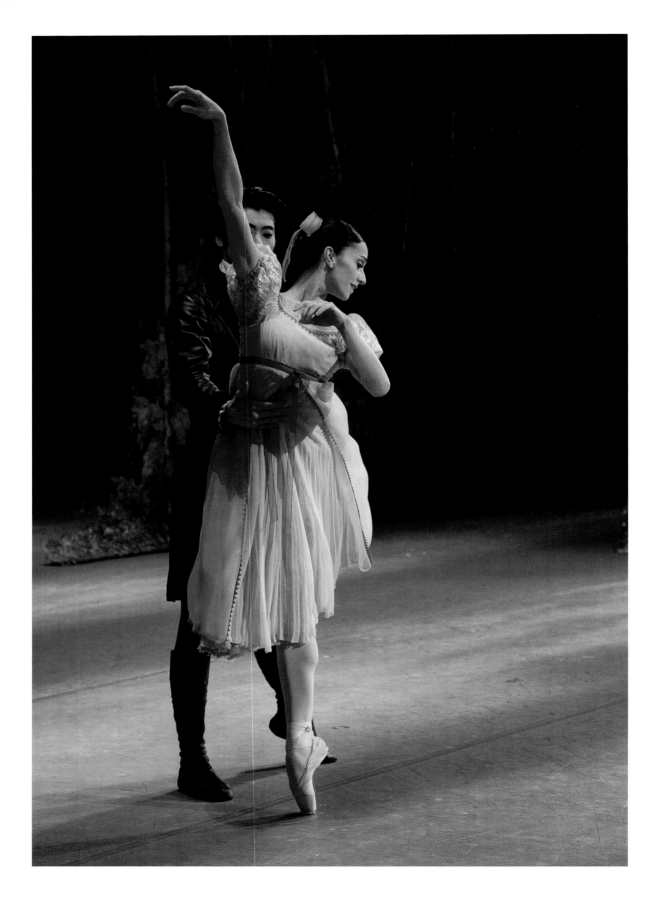

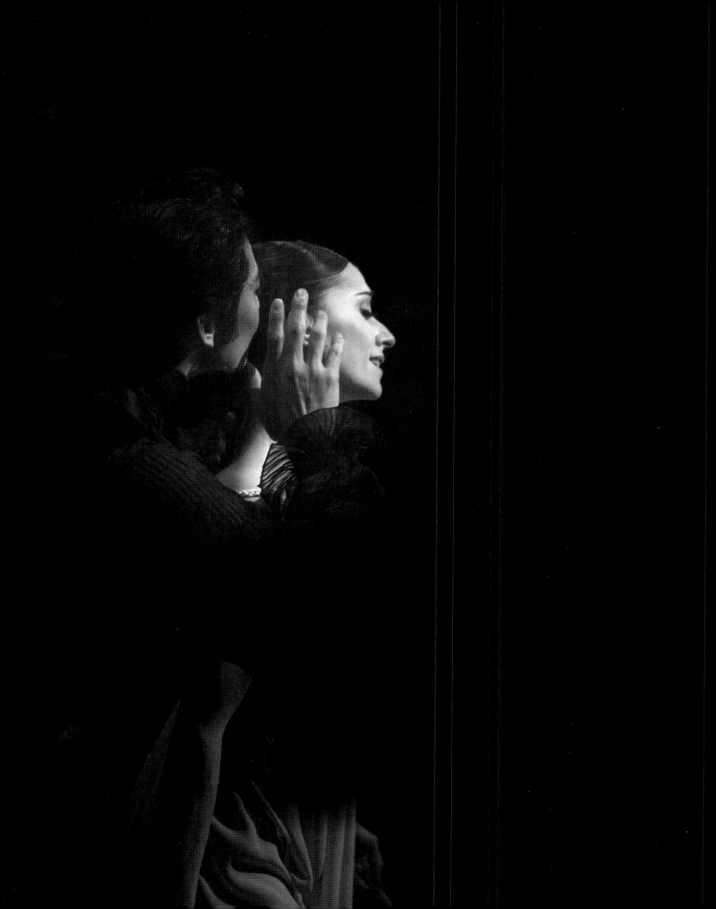

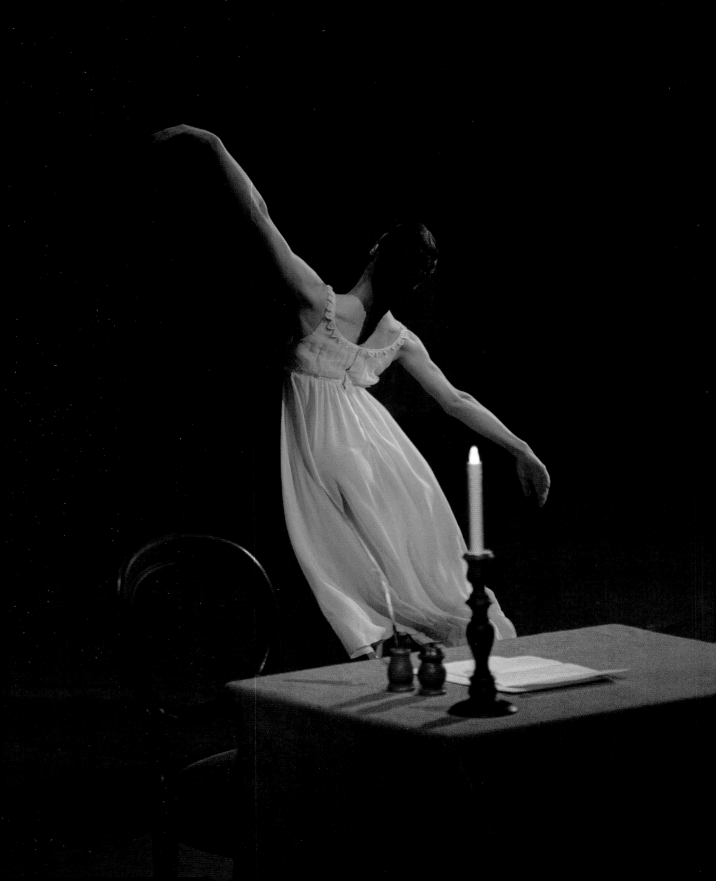

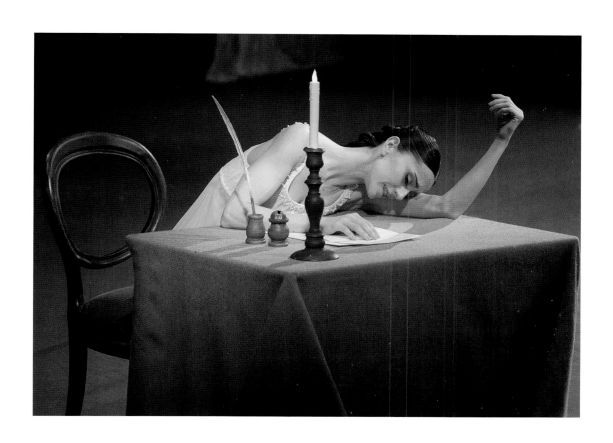

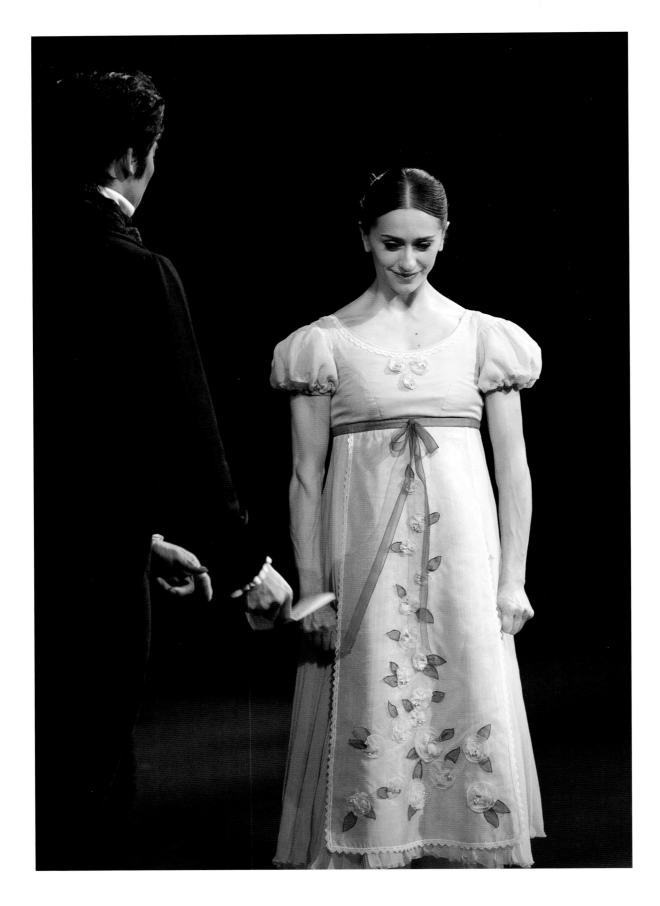

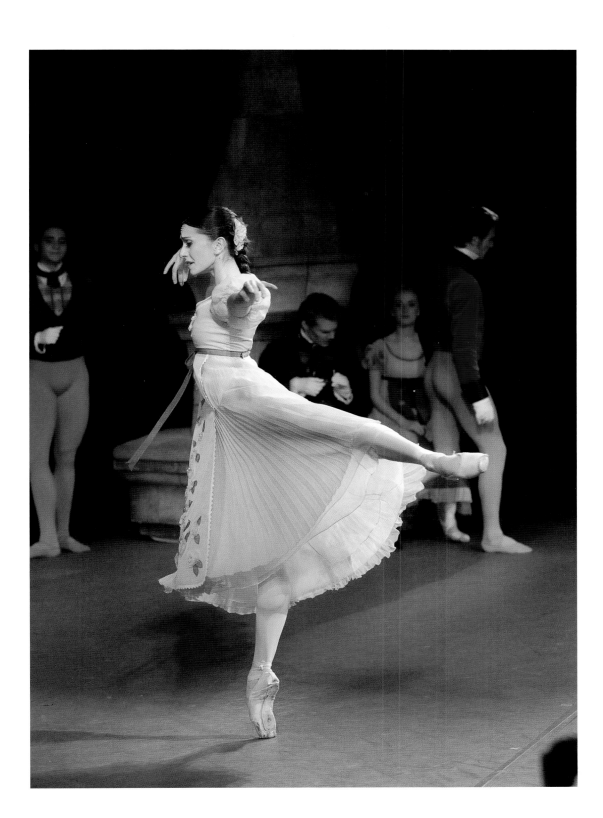

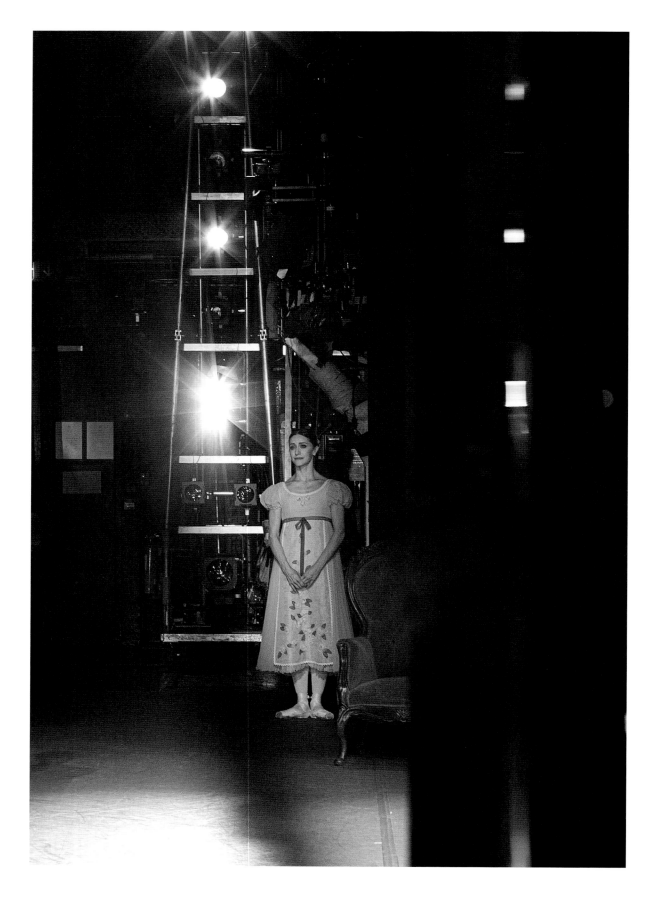

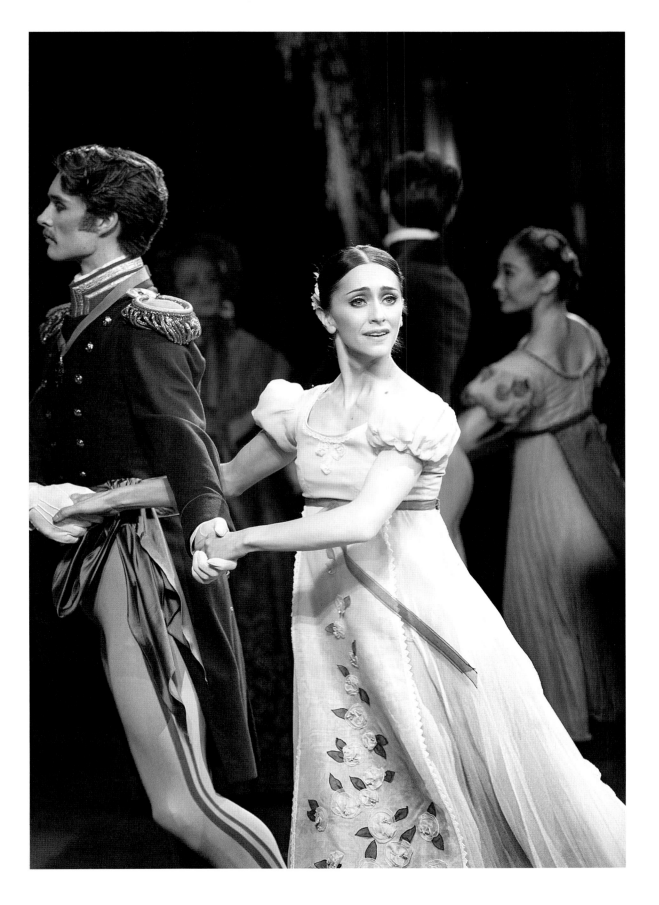

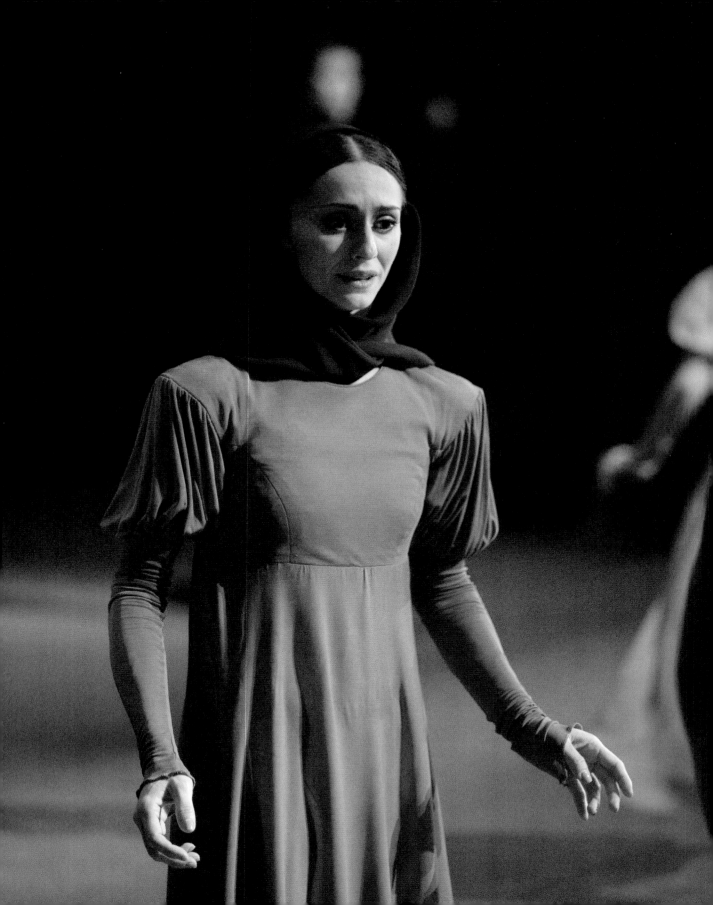

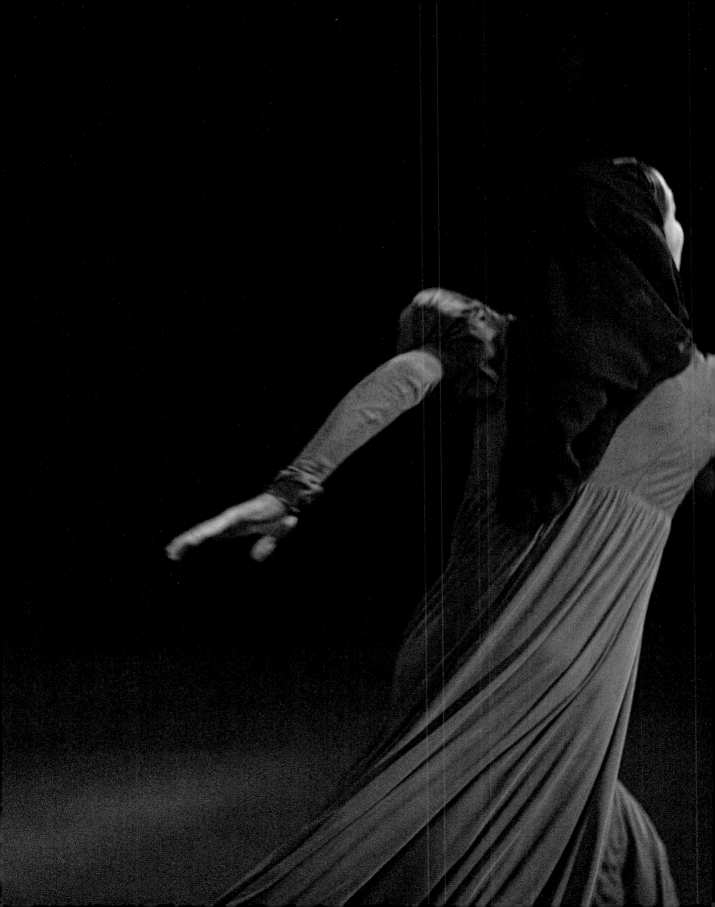

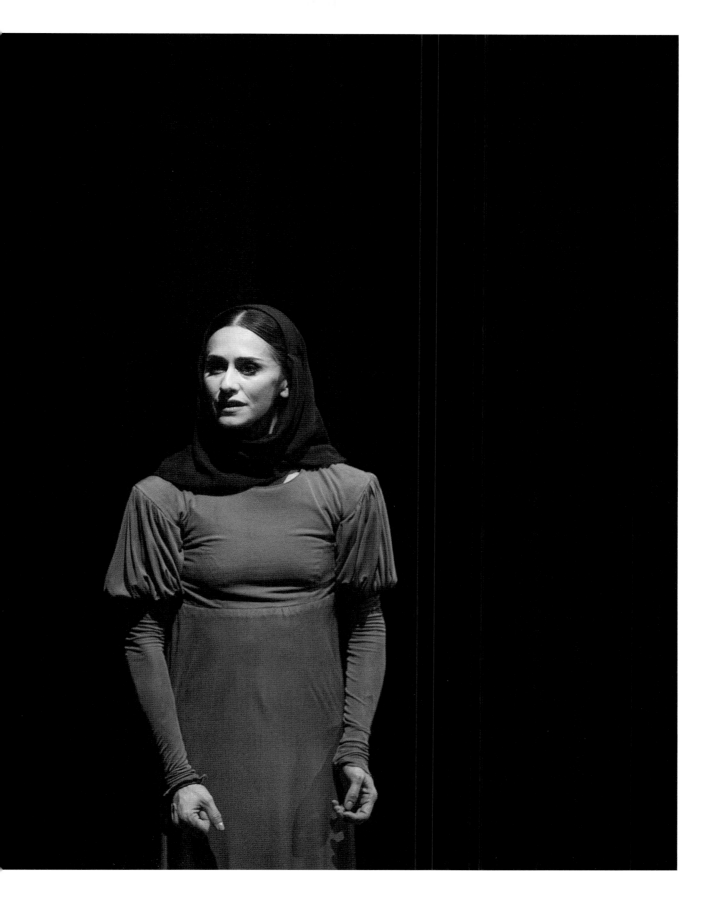

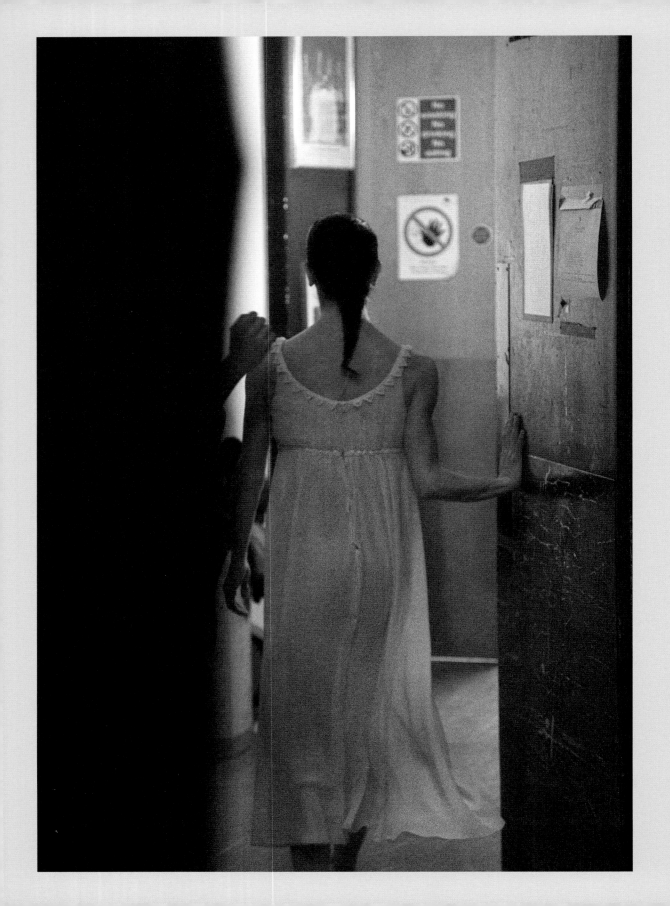

*I've grown up at the Royal Opera House,
as a person and as an artist.*

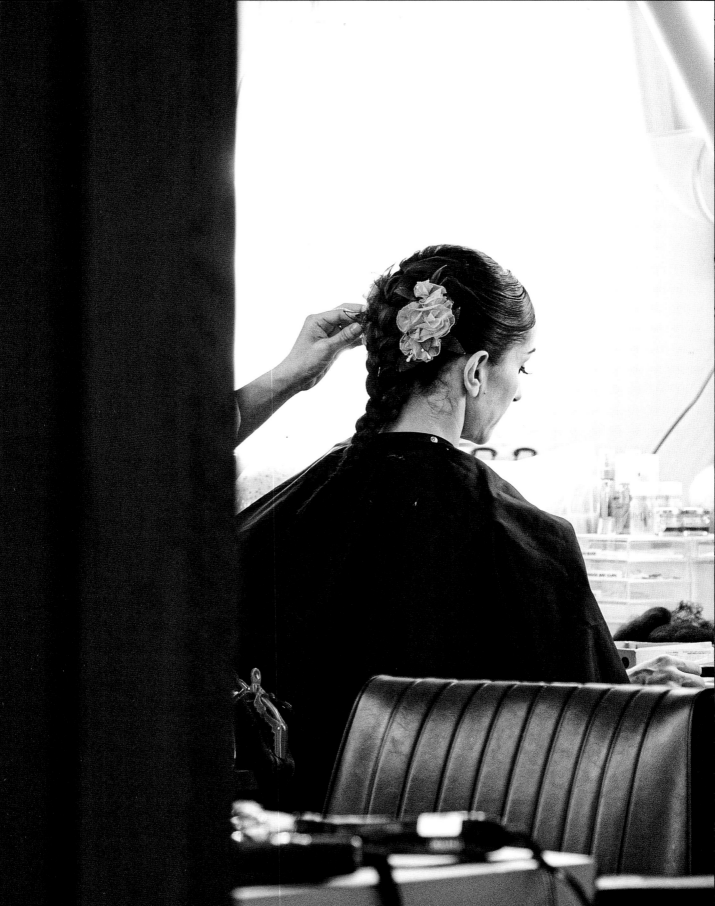

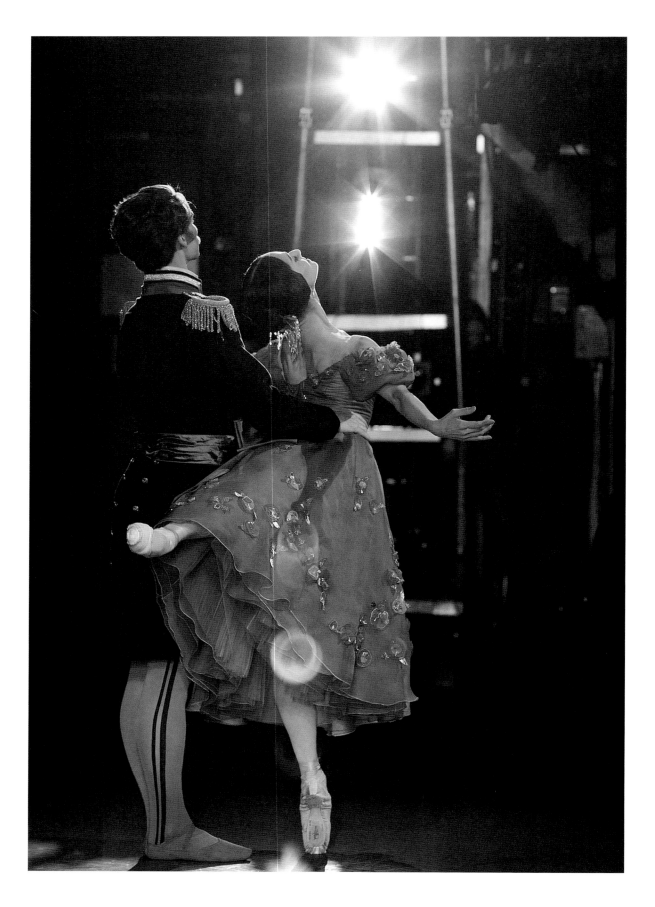

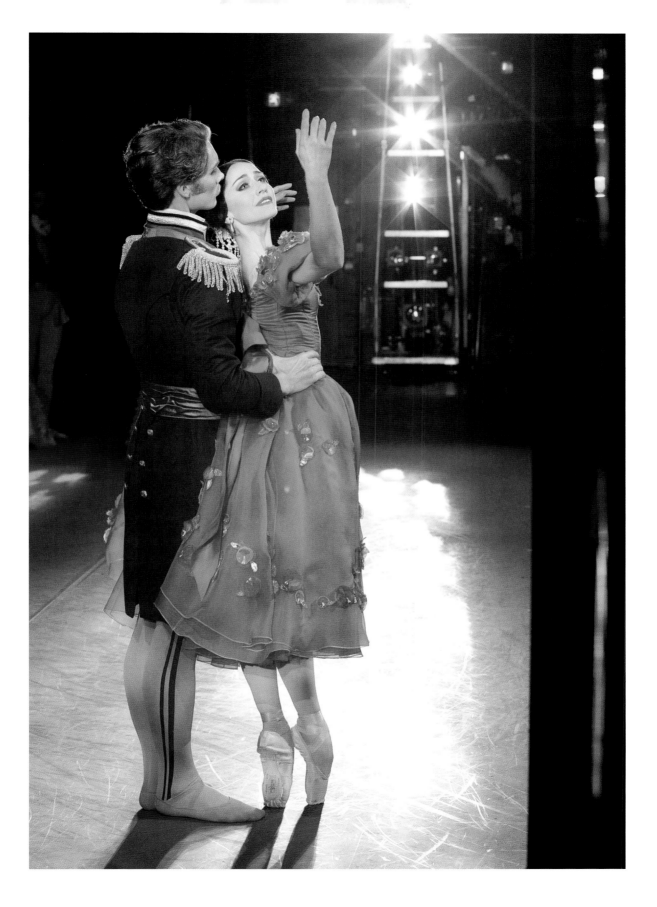

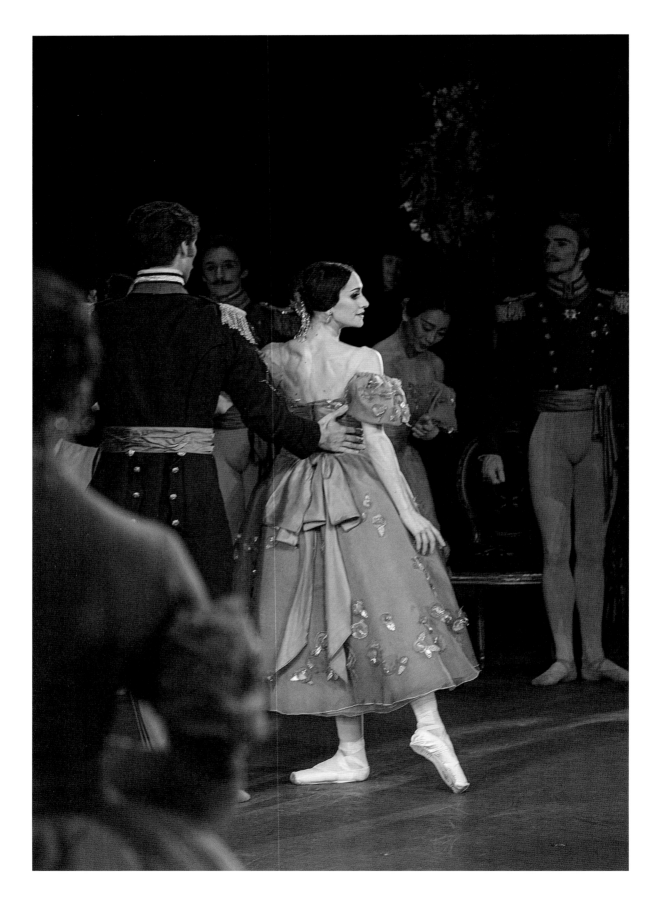

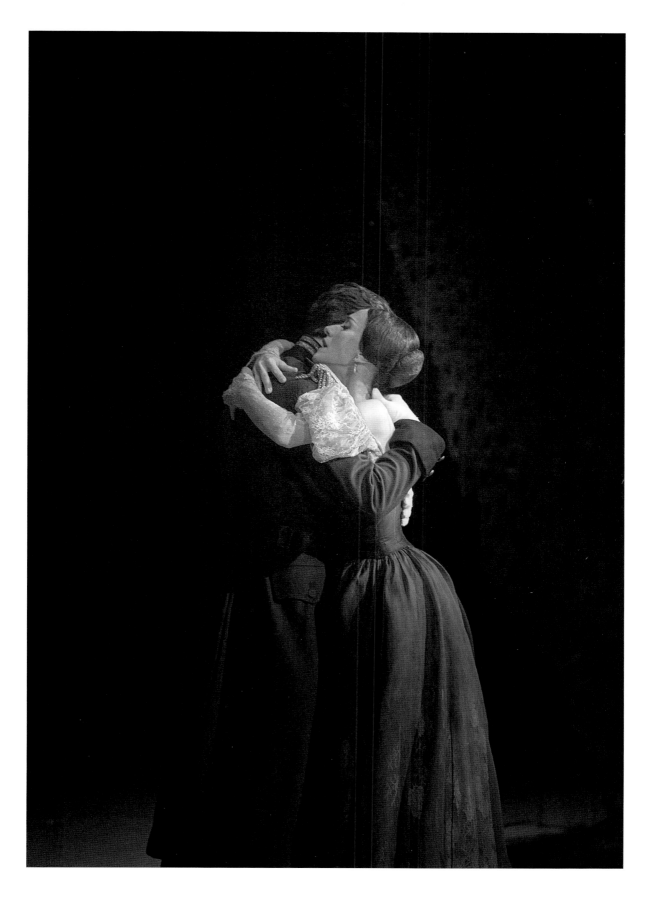

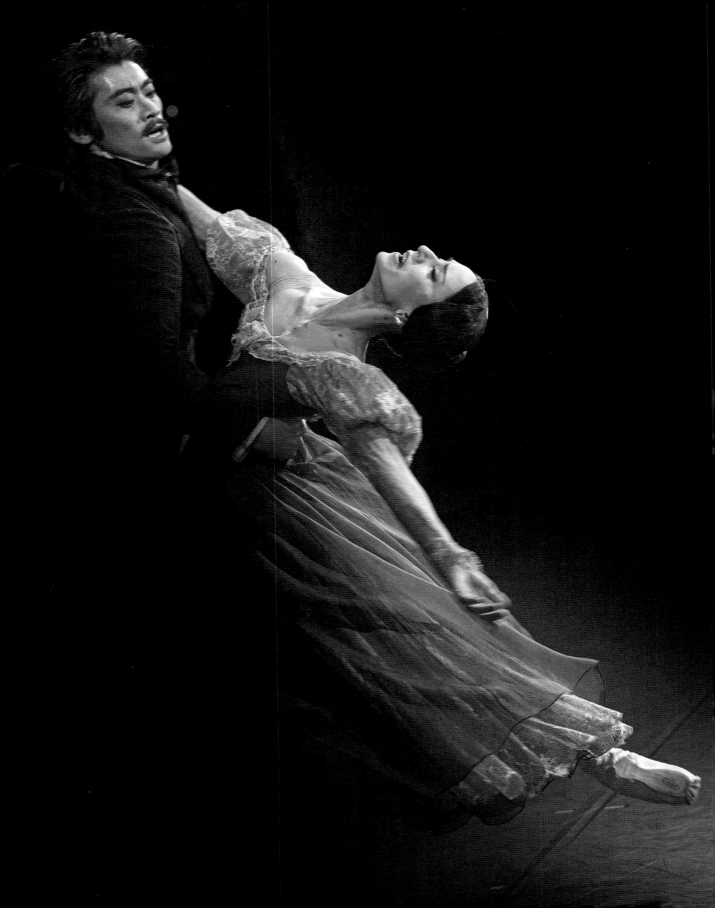

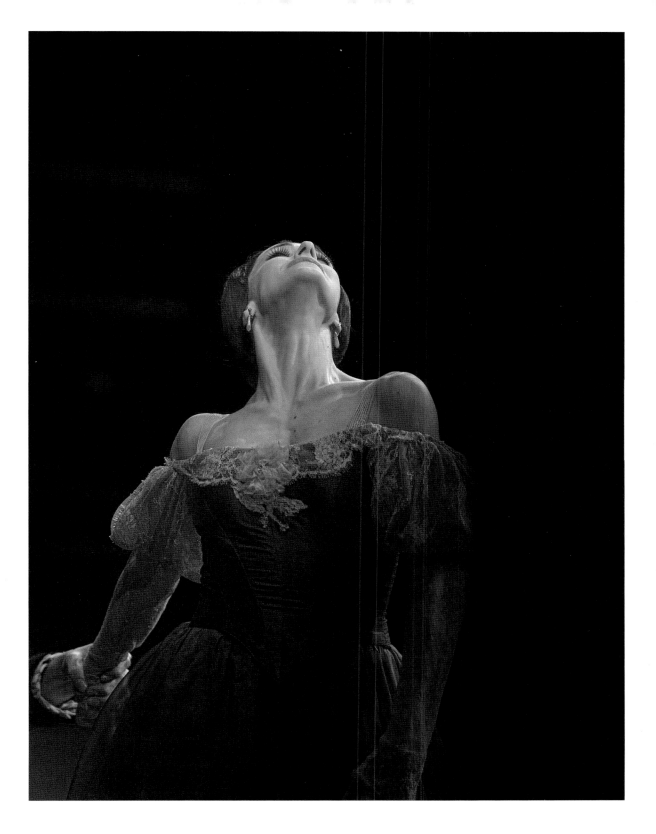

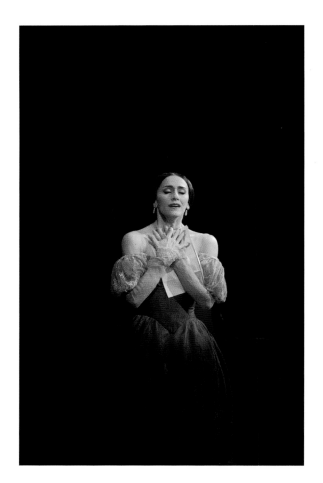
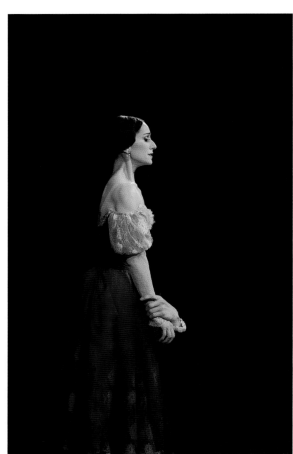

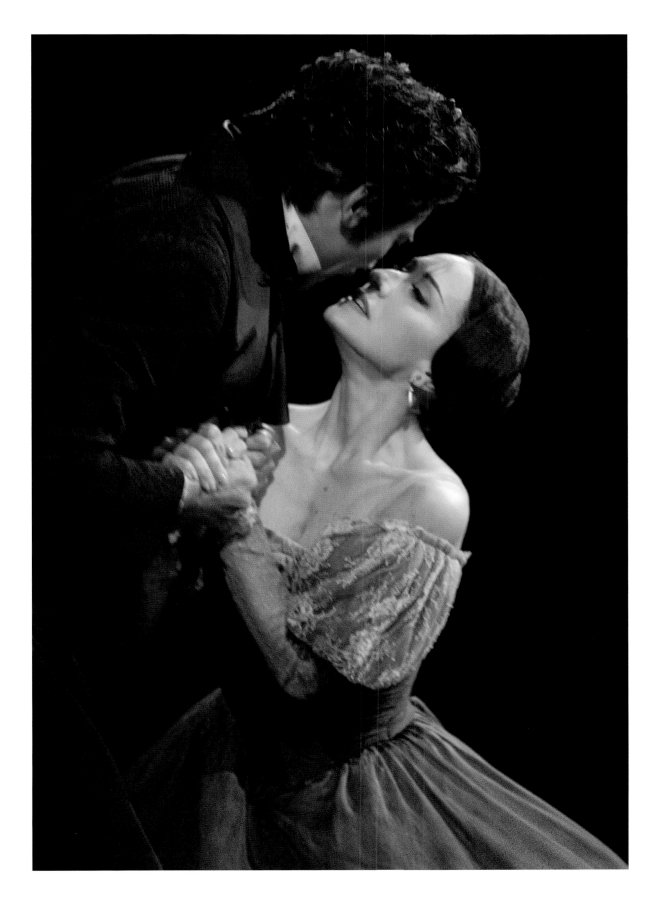

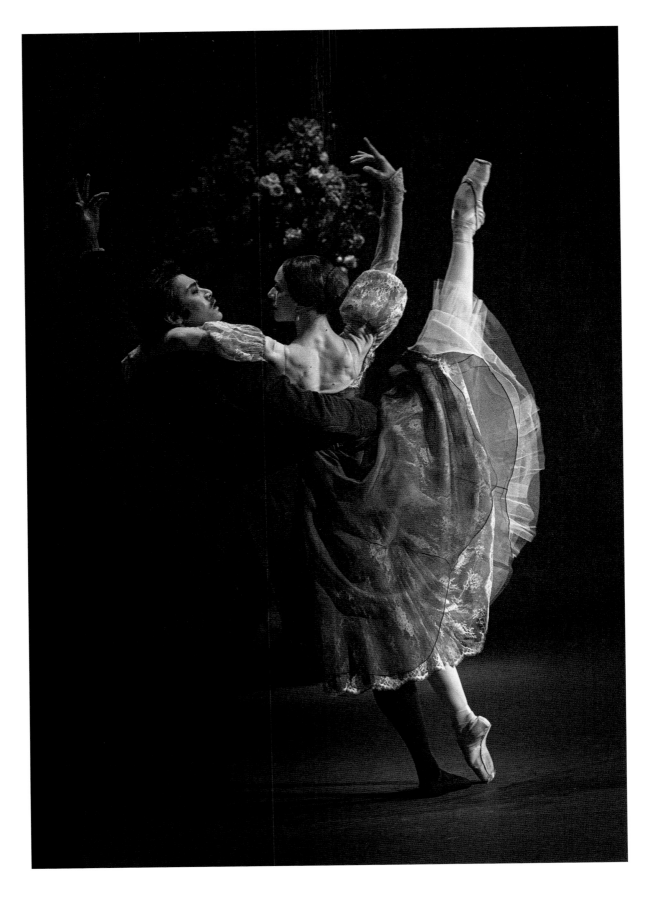

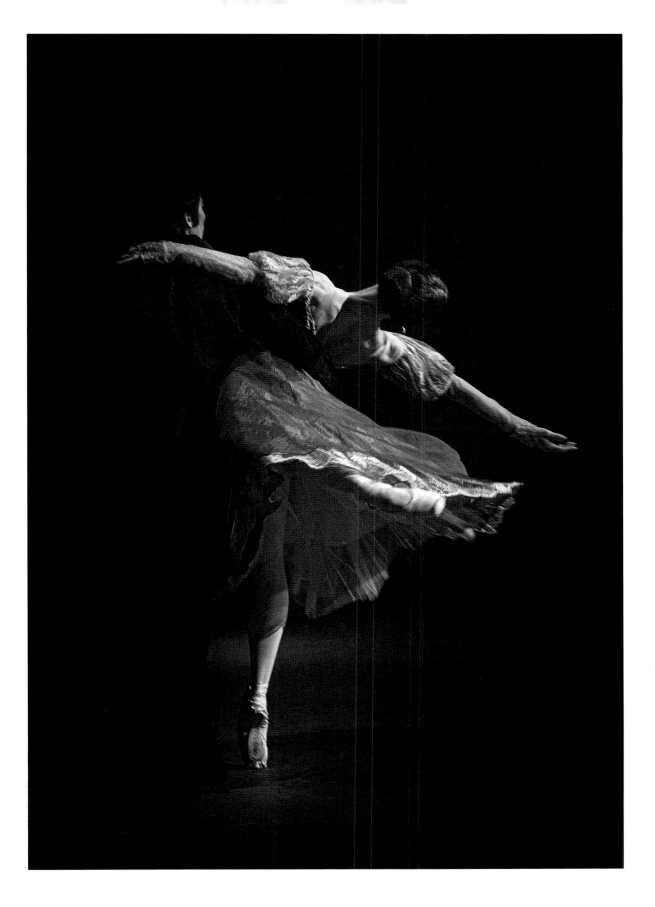

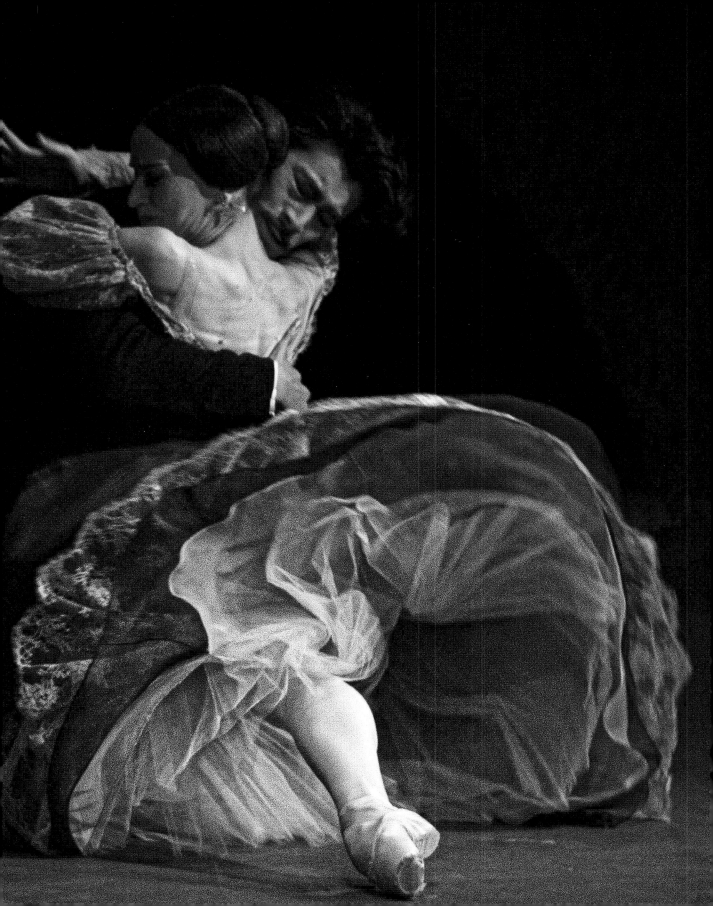

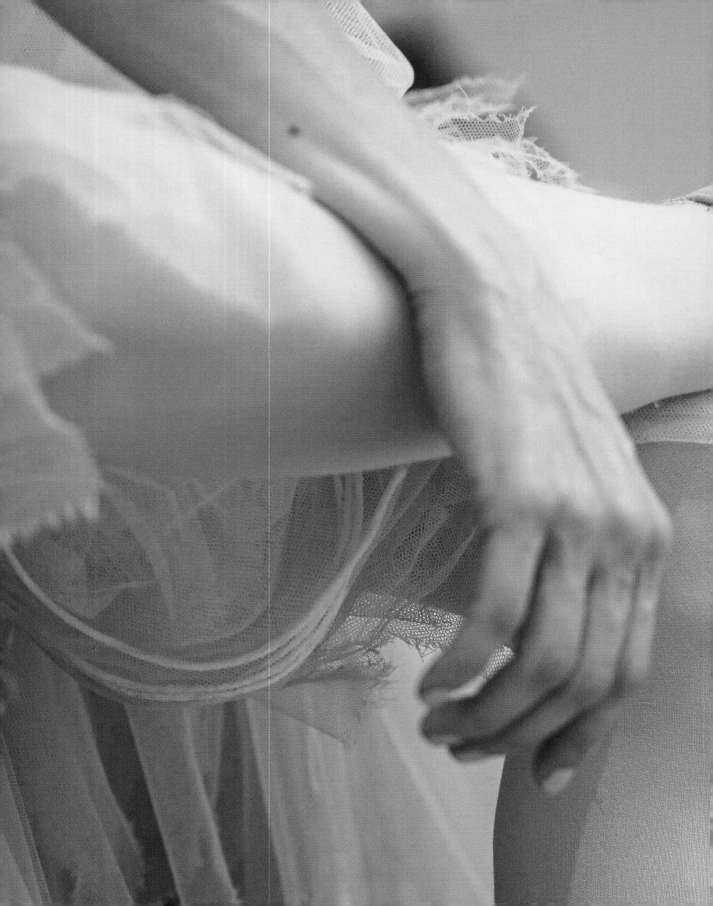

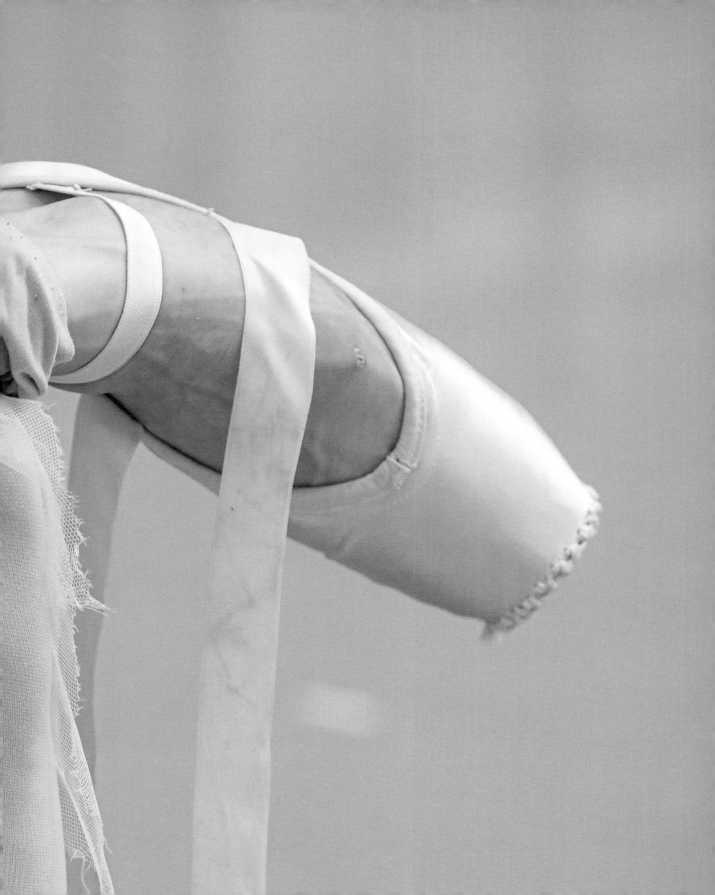

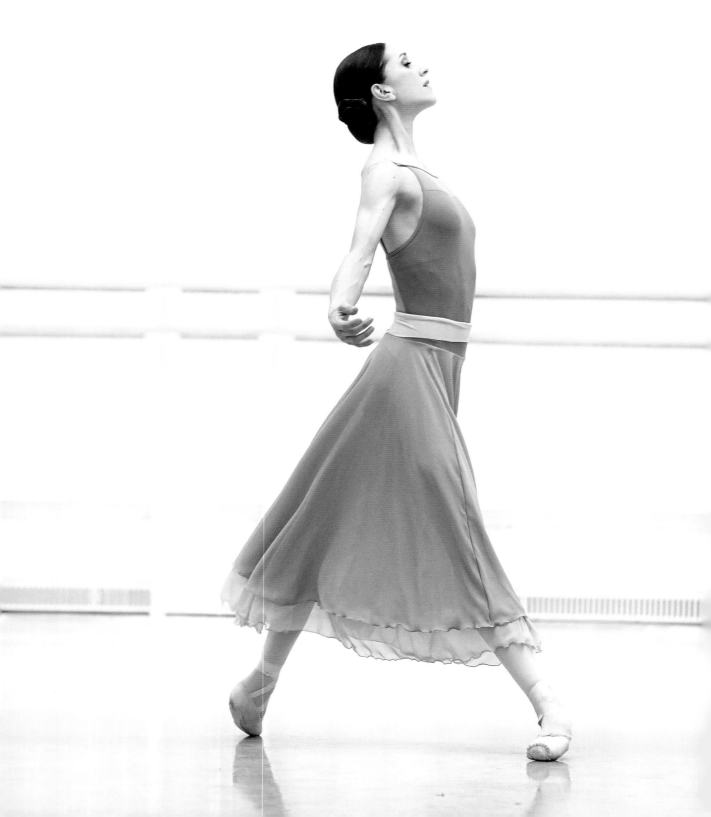

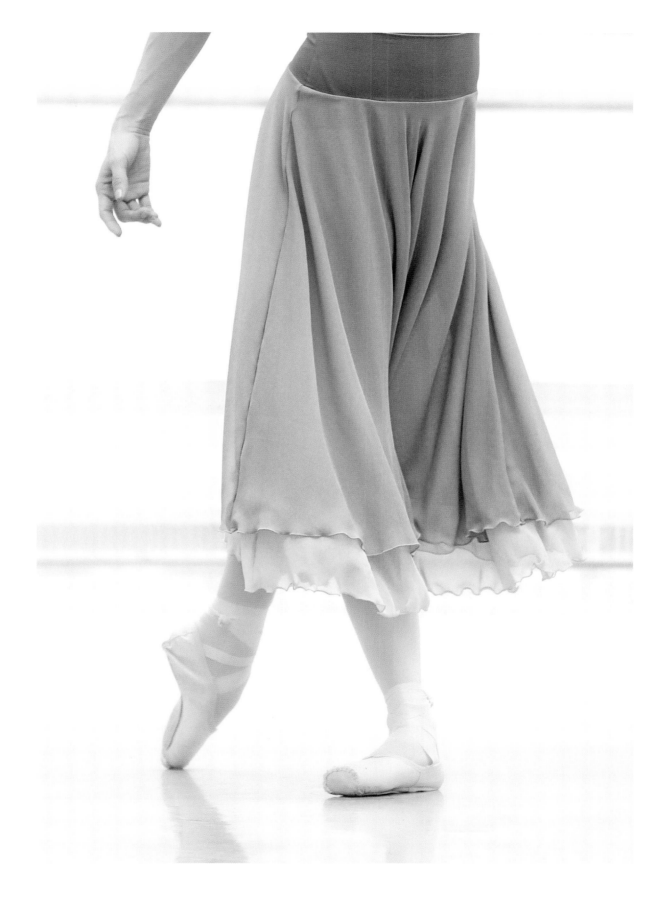

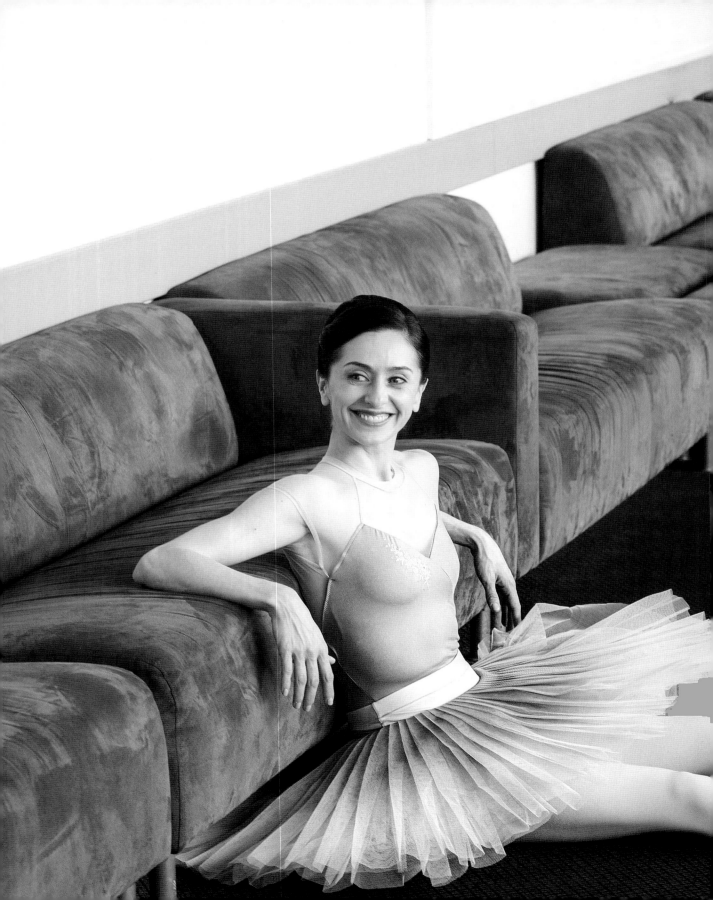

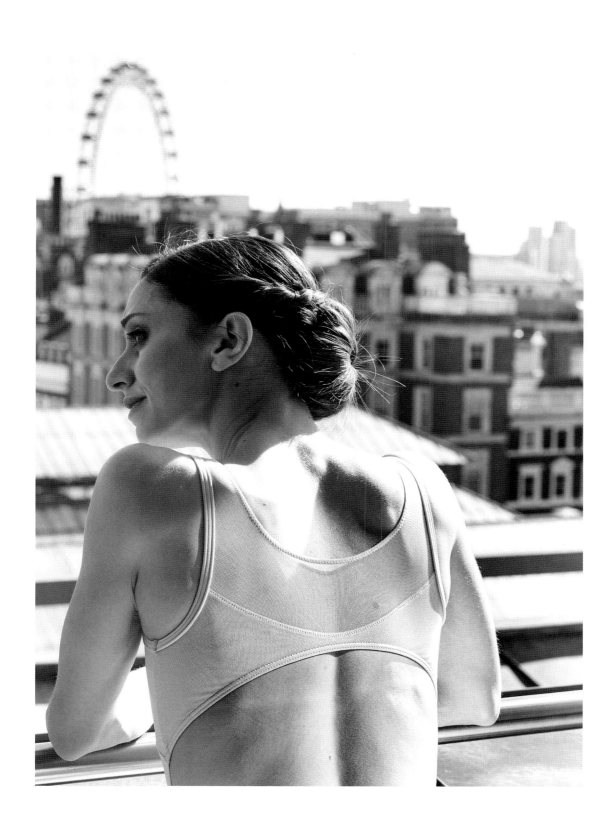

WITH THANKS

It has been a blessing working with Maria-Helena and Rachel Hollings on this special project. For years I have been trying to articulate my feelings and vision for this art form. Now with these images from Maria-Helena, and the words by Rachel conjured up from our many conversations, I feel we have landed on the perfect expression of how ballet touches the soul. My heart is truly full. Thank you both.

I am humbled by the opportunities afforded me over the years as a dancer. I am forever grateful to the ballerinas, coaches and directors who have inspired and guided me during my journey – to Anthony Dowell who gave me my first contract with my dream company, to Ross Stretton who made me a Principal, to Dame Monica Mason who shaped me and continues to light my way, and to Kevin O'Hare for his artistic integrity, humanity and brilliant knack of making me laugh. I am also grateful to the directors and company members worldwide who welcome me so warmly to their international stages.

Where would I be without my fantastic dance partners? My thanks to all of them, including those featured in this book: Vadim Muntagirov, Federico Bonelli, Ryoichi Hirano, William Bracewell and Lukas Bjørneboe Brændsrød. The artistry of all my partners inspires me. I also deeply value my wonderful friends and colleagues at the Royal Opera House: my fellow dancers, the artistic staff, the magicians in the costume, wigs and make-up department, and all the wonderful technical, healthcare, administrative, catering and stage door teams who make this place home.

I extend grateful thanks to Chacott and Freed of London for enabling Maria-Helena to travel to London to capture so many studio shots as part of my Nela dancewear line. Thanks also to Claire Young and the team at Scala Publishing for believing in this project, to Jane Storie and Maud Stiegler at the Royal Opera House for enabling it to happen, and to Joe Ewart for his elegant design eye.

My ultimate gratitude goes to my family for their unwavering love and support – to my parents and Alejandro, to my feline heroes Romeo and Lionel and their angelic godmother Fanny Boselli, and to my close circle of friends who are my rock. And, of course, I must thank my treasured audiences around the world whose passion and enthusiasm keep the flame of ballet alive. I would not be here without you.

All photography © Maria-Helena Buckley, 2023

Commissioned by Royal Opera House Enterprises

Text/Creative Consultant: Rachel Hollings

This edition © Scala Arts & Heritage Publishers Ltd, 2023

First published in 2023 by
Scala Arts & Heritage Publishers Ltd
43 Great Ormond Street
London WC1N 3HZ
www.scalapublishers.com
10 9 8 7 6 5 4 3 2

ISBN: 987 1 78551 473 9

Editors: Claire Young and
Johanna Stephenson
Designer: Joe Ewart
Printed in the Czech Republic

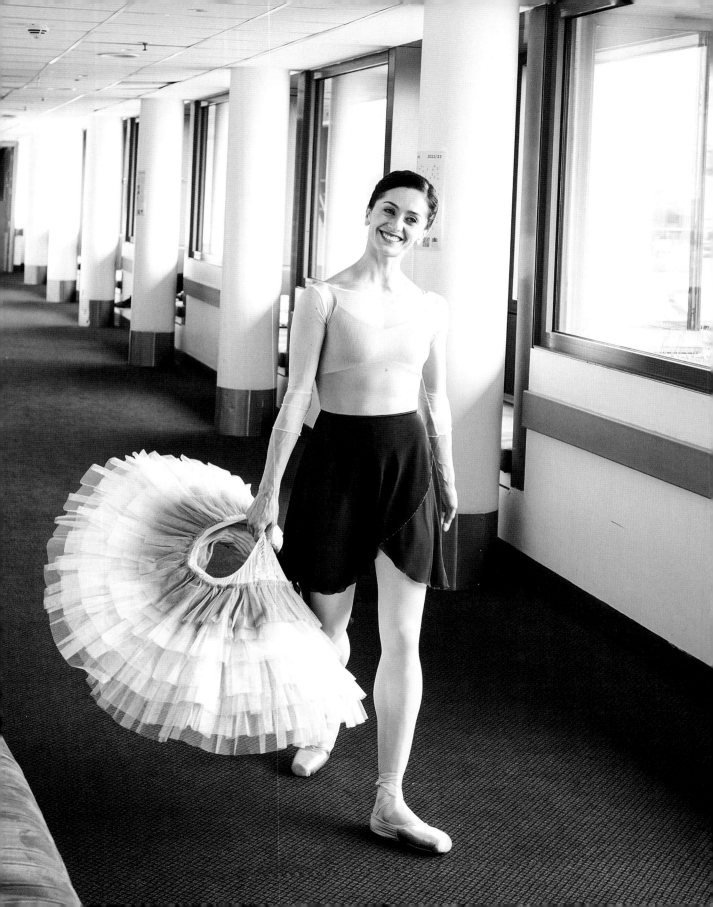